Maggie's Way

Maggie's Way

Observations from Below Your Knees

Bill Stanton

Andrews McMeel
Publishing

Kansas City

Maggie's Way

copyright © 2001 by Bill Stanton. All rights reserved. Printed in China.
No part of this book may be used or reproduced in any manner what-
soever without written permission except in the case of reprints in the
context of reviews. For information, write Andrews McMeel Publishing,
an Andrews McMeel Universal company, 4520 Main Street, Kansas City,
Missouri 64111.

00 01 02 03 04 RDS 10 9 8 7 6 5 4 3 2 1

Library of Congress Cataloging-in-Publication Data
Stanton, Bill, 1946–
 Maggie's way : observations from below your knees / Bill Stanton.
 p. cm.
 ISBN 0-7407-1216-0 (pbk.)
 1. Basset hound—Pictorial works. 2. Photography of dogs. I. Title.
SF429.B2 S76 2000
636.753'6—dc21 00-042103

Book design by Holly Camerlinck

Introduction

Life should be a simple affair.

Eat, sleep, play, and an occasional nap in the afternoon sun.

But, as we all know, reality is messier than that. Over the course of my seven years I have come to see that living a civilized life of ease is not as simple as falling asleep on the floor. Now that I have entered my slower, more thoughtful years, I have obtained a rather serene existence. Eat, sleep, and just a modicum of play are now the cornerstones of my daily routine. But as casual as this current lifestyle may appear, it is the result of considerable thought and tenacious effort.

As someone—was it Aristotle?—once said, "Satisfaction is derived in equal proportion to the energy expended to achieve it."

As a blithe and bouncy pup of six months, I hadn't a clue of the obstacles that lay before me. I had come, under circumstances that are still a mystery to me, to live with three friendly but woefully misguided humans known as the Stanton family.

Initially they were a wild and irrational bunch prone to dramatic overreaction. There was the inevitable flurry of arm waving and heated exclamation whenever I tried to test my new teeth or relieve my bladder. But gradually, a process of mutual education took place. I came to acknowledge their interests, however irrelevant, and have altered my behavior accordingly. In return, the affectionate and teachable Stantons have come to accept the priority of my needs.

Foremost among the issues of conflict was that of couch access. There are many spots in the house where I enjoy taking my ease—the window perch (window open, of course), that sunny spot near the radiator, the patch of floor in the hallway where the traffic is heaviest, and even on occasion that amusing little basket in the corner they call my bed. But early on, I discovered that the right armrest of the large gray couch was the most comfortable spot to rest

my weary head after a hard day. Needless to say, that couch was deemed off-limits. I was rudely evicted every time I tried to settle in. Well, it has taken years, but by virtue of my steely strength of will, the Stantons have come to see the error of their ways. Now, all acknowledge that the couch has become ground zero of my snooze central. Arm waving and excessive shouts are happily a thing of the past.

In the process of gaining my current position of ease I have learned a thing or two about life. And as a magnanimous hound, I think it only fitting to share the insights I have gained from the vantage point of my privileged lower position.

As someone said, I think it was Louis Pasteur, "My secret lies solely in my tenacity." I couldn't have said it better myself.

Maggie

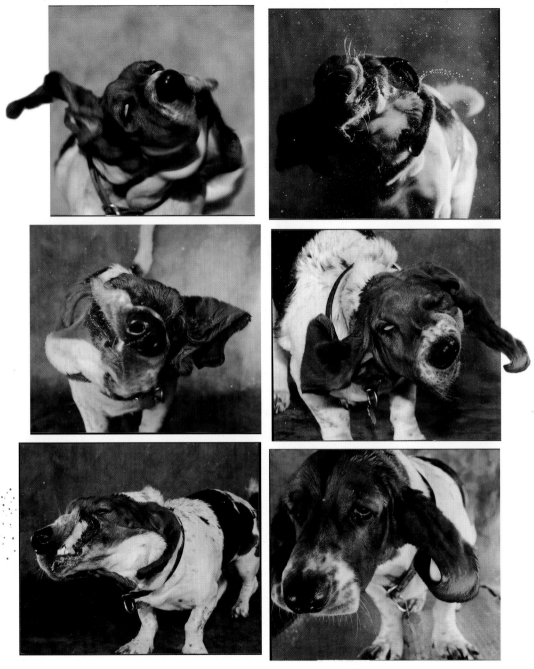

All things are the offspring of flux and motion.

—Socrates

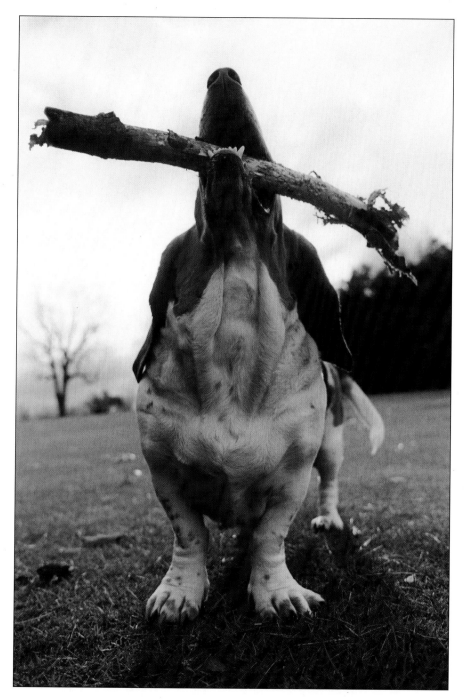

Low-tech joystick.

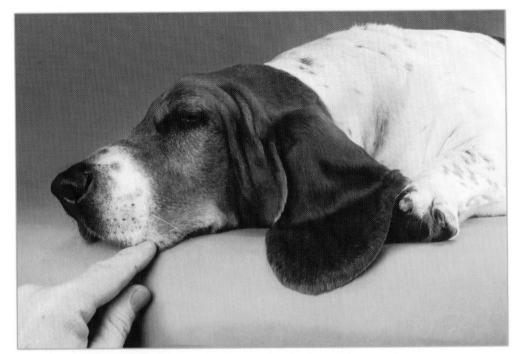

Beneath the calm exterior lurks a darker self.

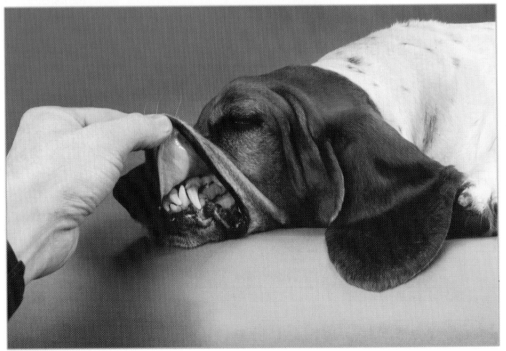

Nothing happens

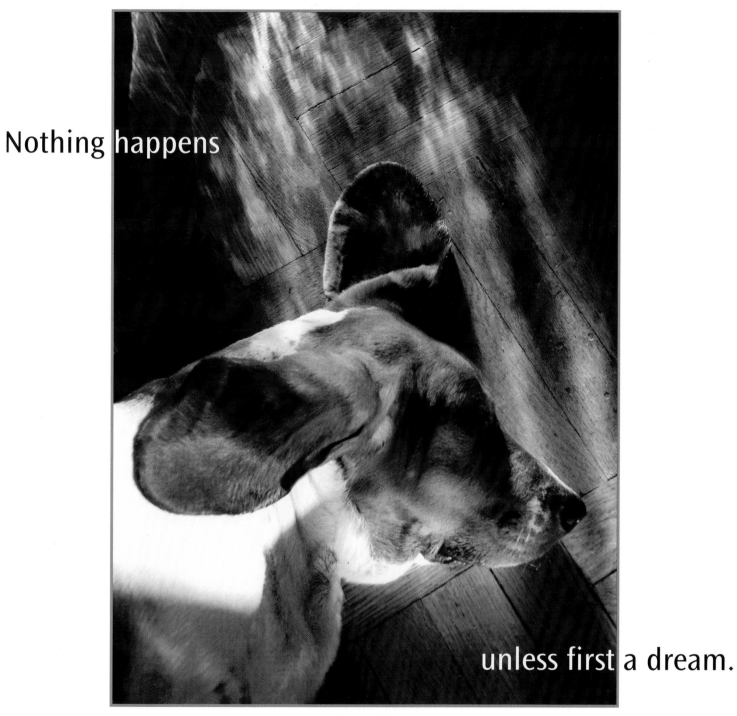

unless first a dream.

—Carl Sandburg

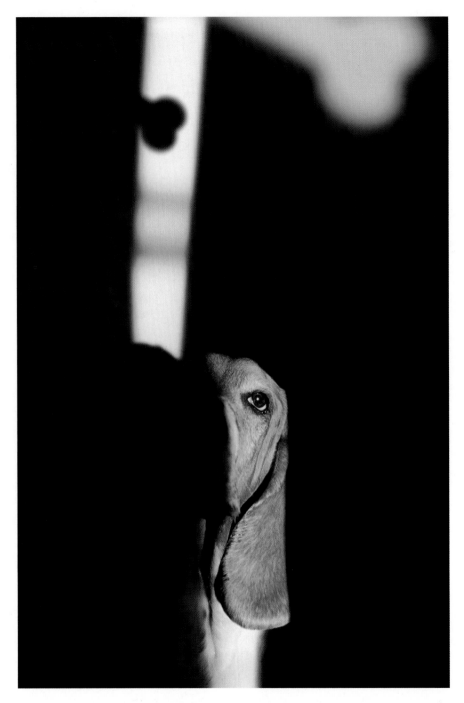

The vision.

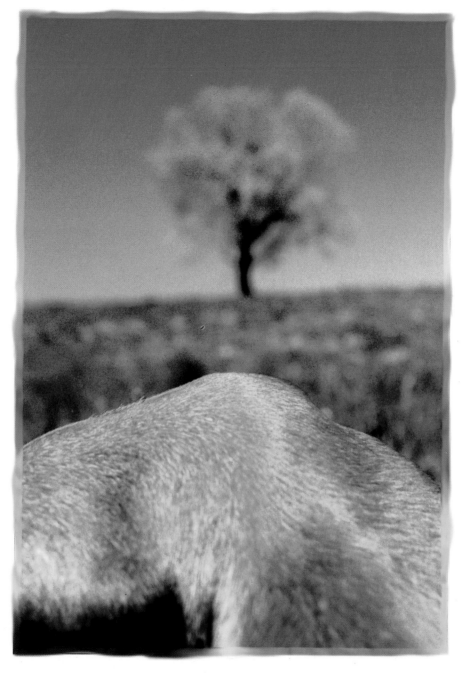

T o p o g r a p h y .

view from

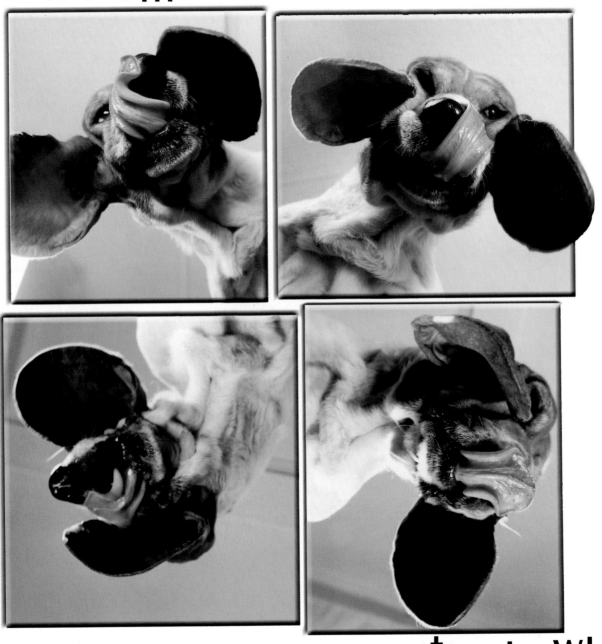

the bowl.

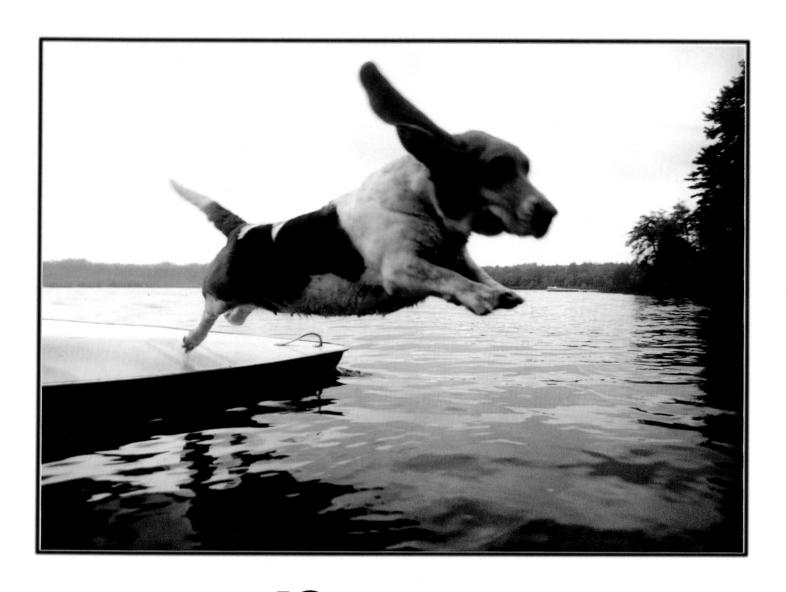

Leap and the net will appear.

The only way to get rid of temptation

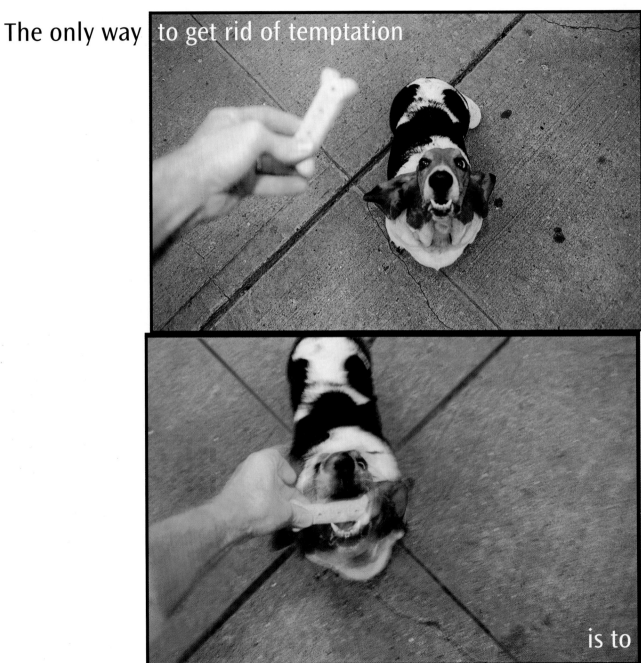

is to yield to it.

—Oscar Wilde

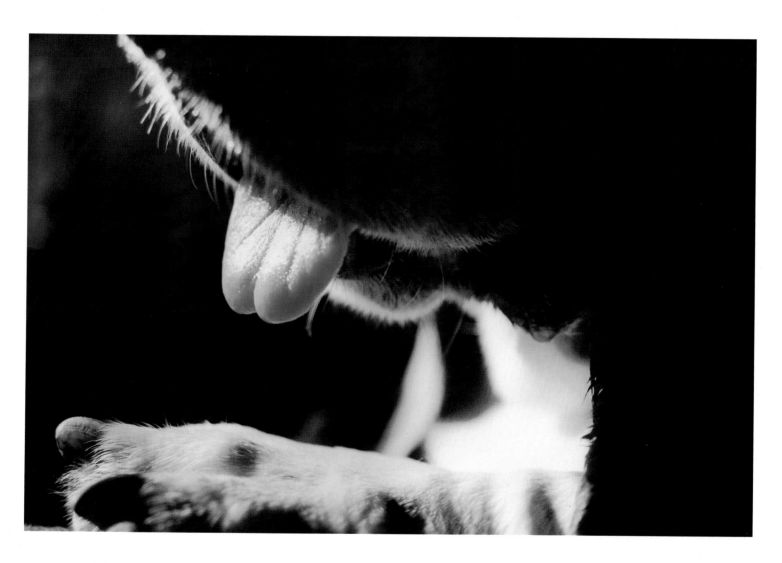

Ventilation unit for temperature-control system.

There are no wrong emotions.

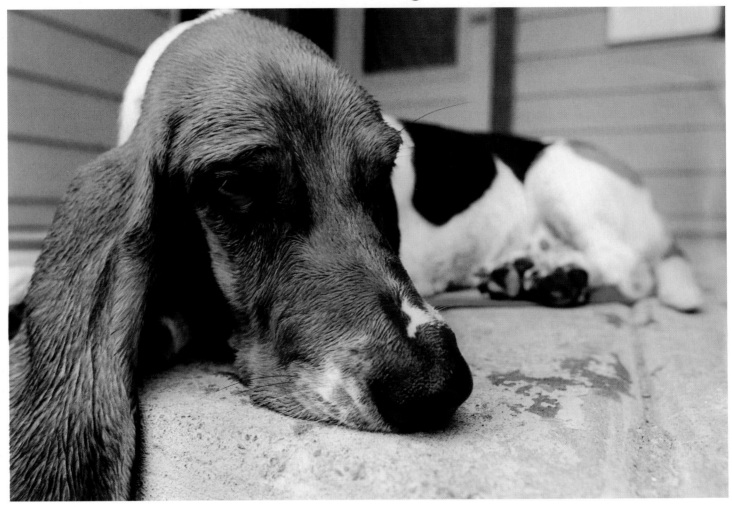

You feel what you feel.

—P. D. James

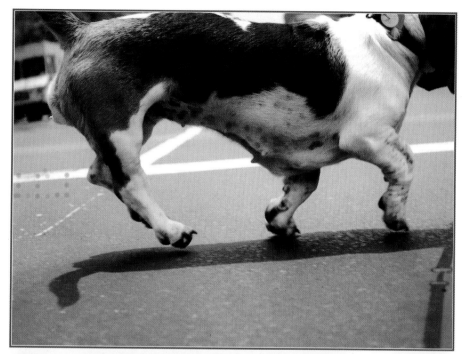

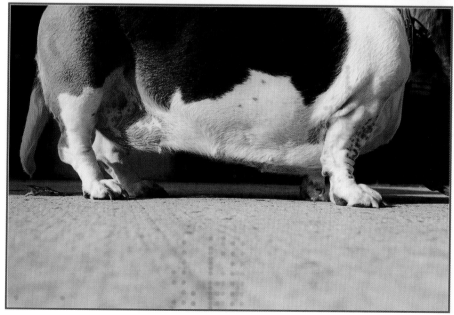

Six years of gravity.

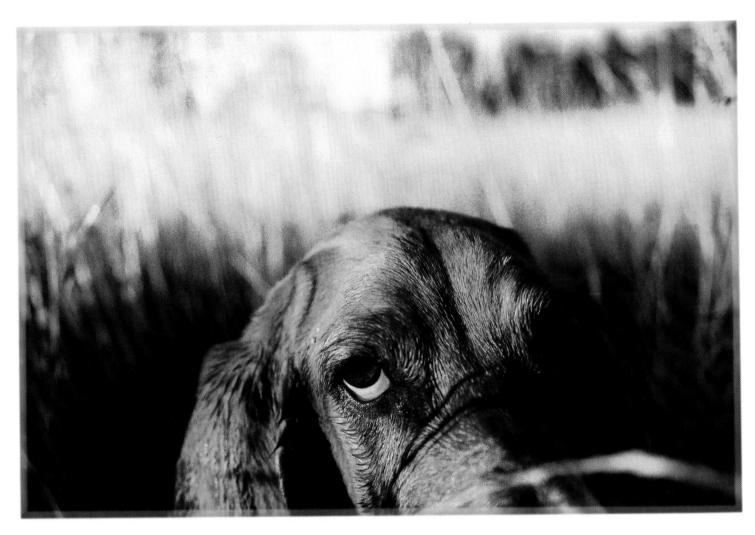

I take a simple view of living. It is keep your eyes open and get on with it.

—Sir Laurence Olivier

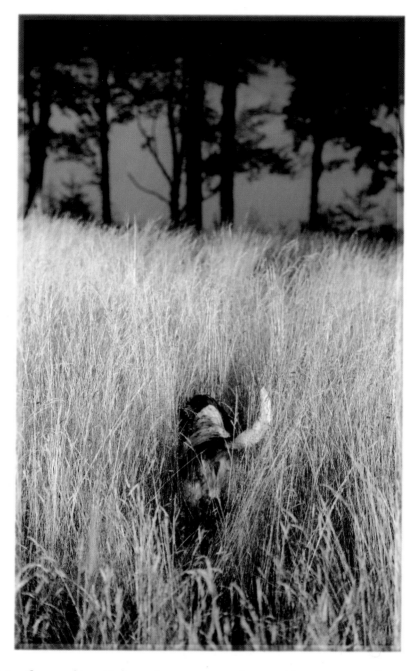

My favorite thing is to go where I've never been.

—Diane Arbus

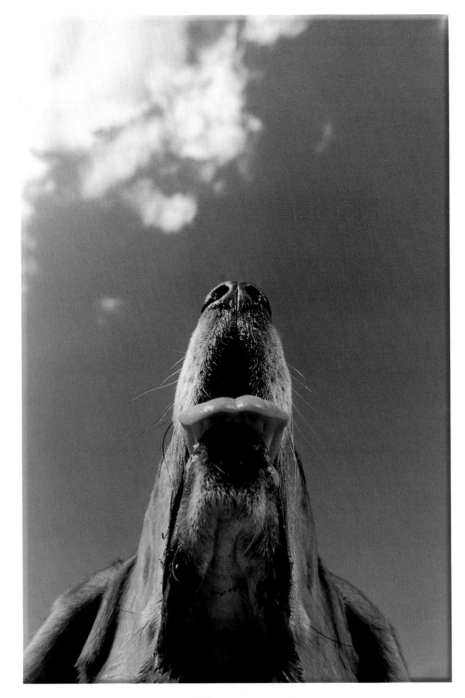

Aerodynamics.

It is sweet to let the mind unbend.

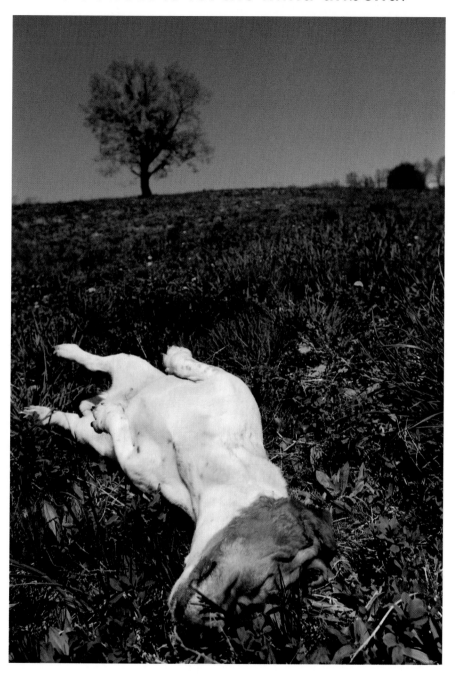

—Horace

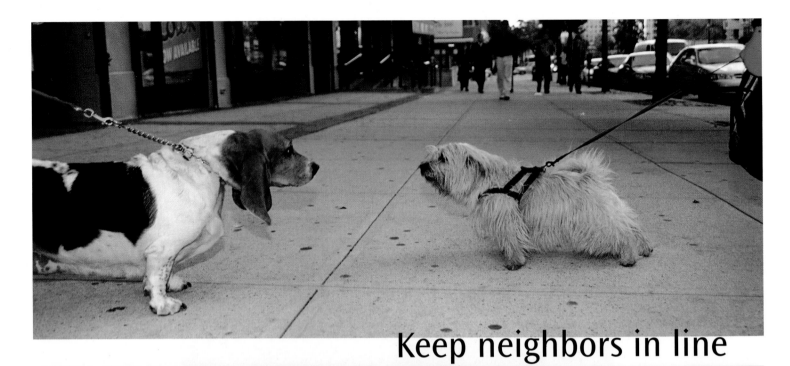

Keep neighbors in line

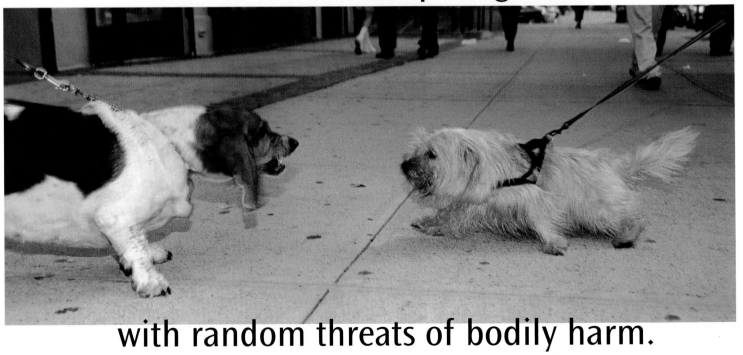

with random threats of bodily harm.

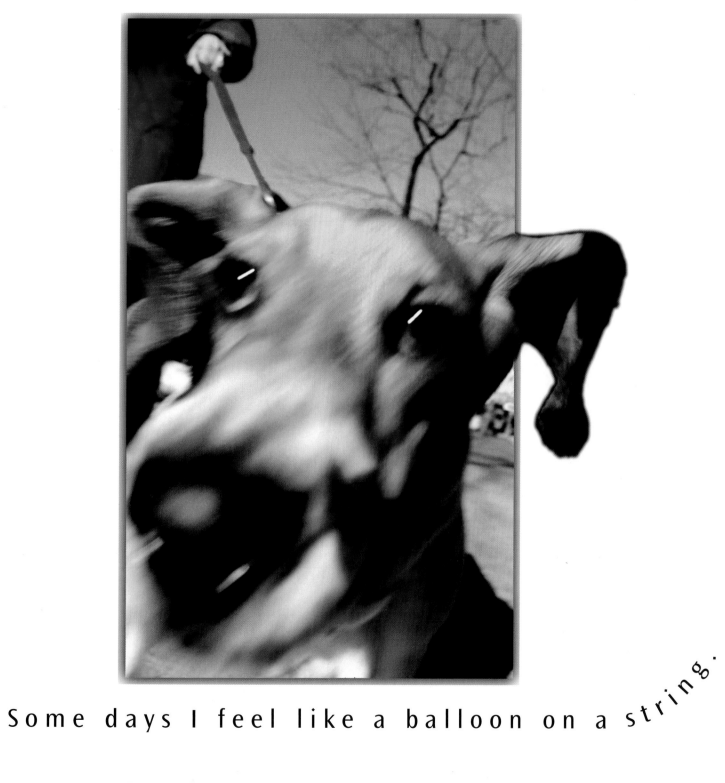

Some days I feel like a balloon on a string.

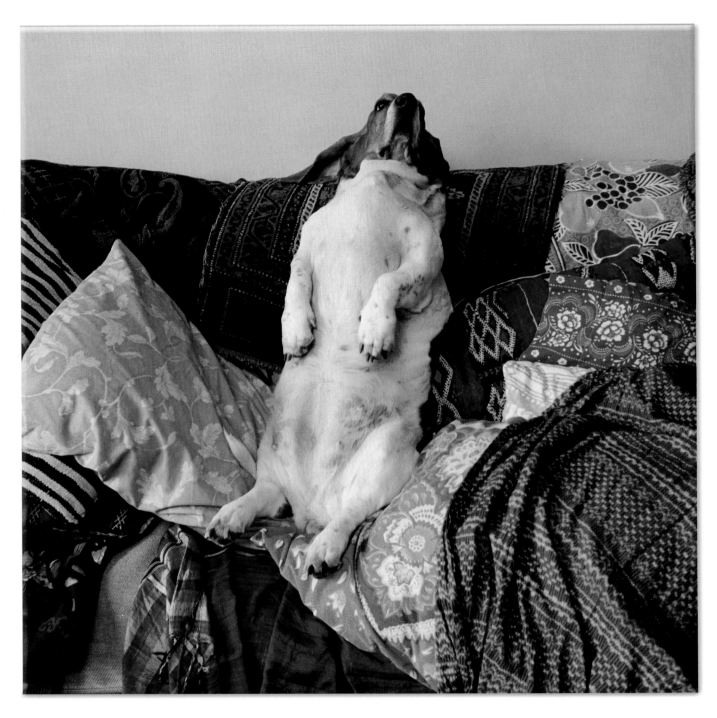

Outrageously pampered dog or penguin seriously out of context?

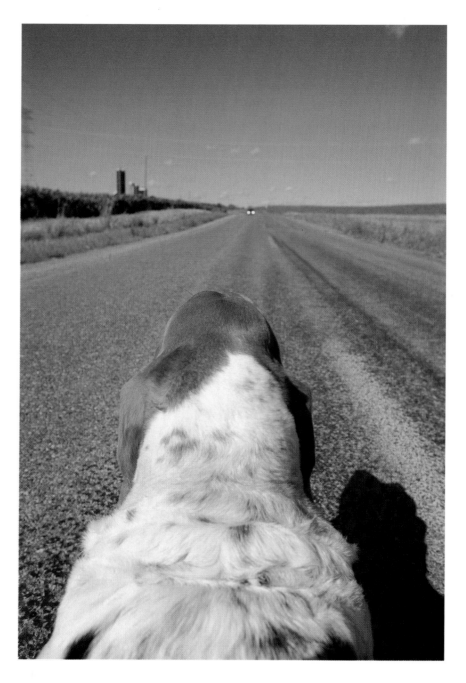

I never worry about the future. It will come soon enough.

–Albert Einstein

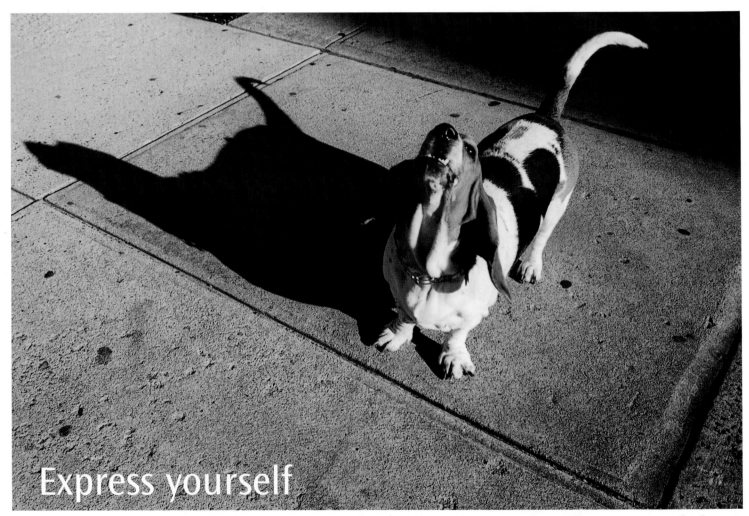

Express yourself
and by so doing change the world.

—Henry Miller

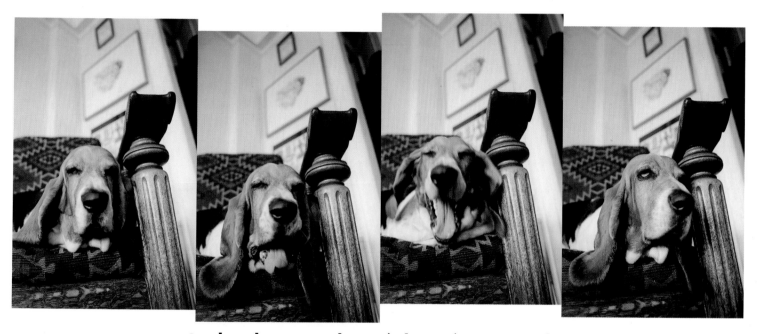

Only those who risk going too far
can possibly find out how far one can go.

—T. S. Eliot

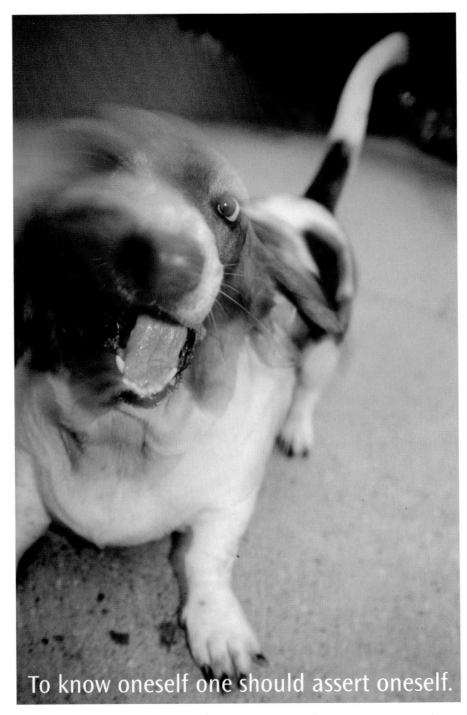

To know oneself one should assert oneself.

—*Albert Camus*

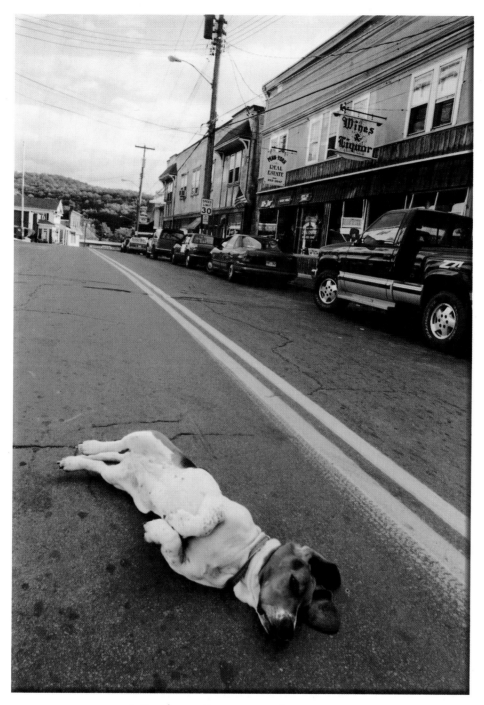

Main Street lounge.

We're all in this alone.

—Lily Tomlin

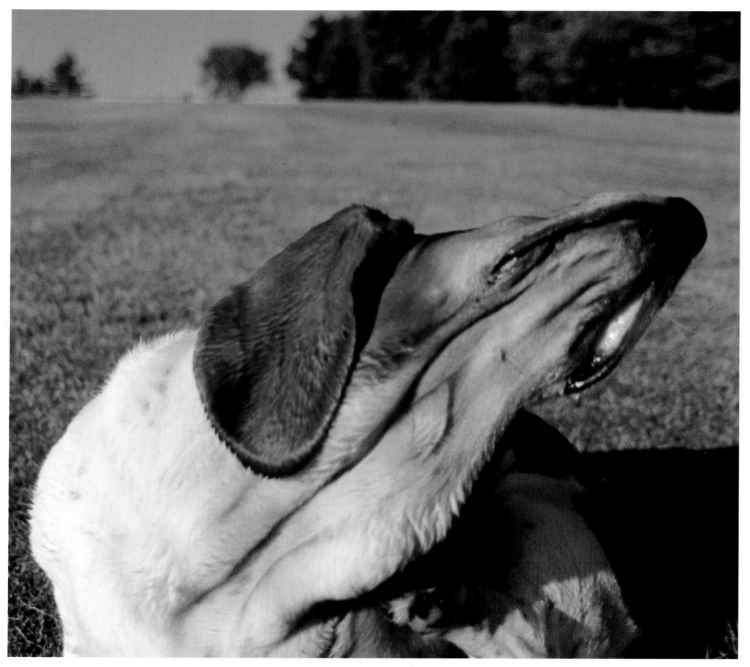

Live and scratch. When you're dead the itching stops.

—*Russian proverb*

Mildly interesting

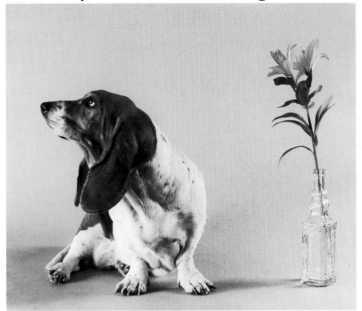 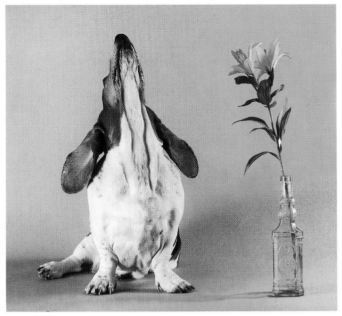

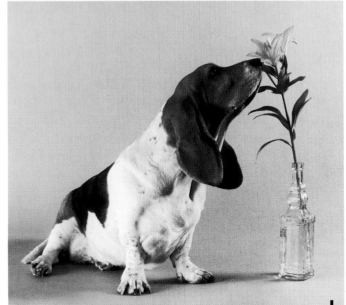 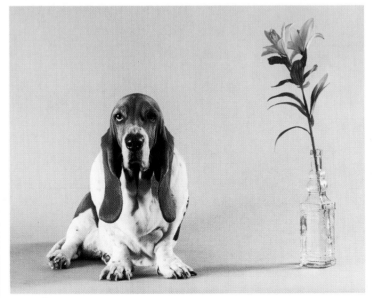

but ultimately irrelevant.

Whenever

I feel

like

exercising

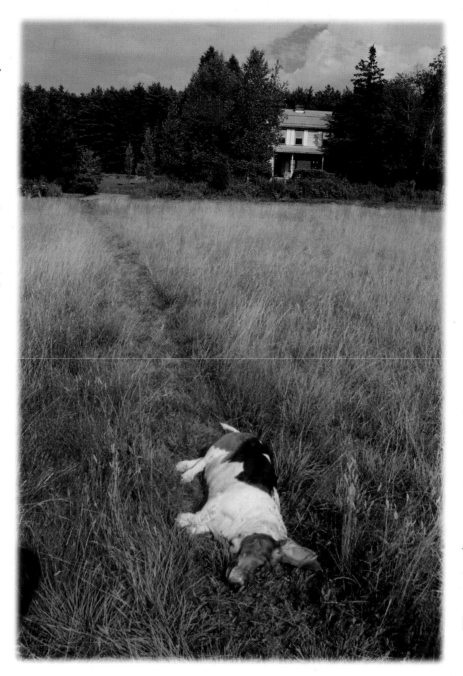

I immediately

lie down

for a while

until the

feeling

passes.

—Mark Twain

If you are not moving toward something

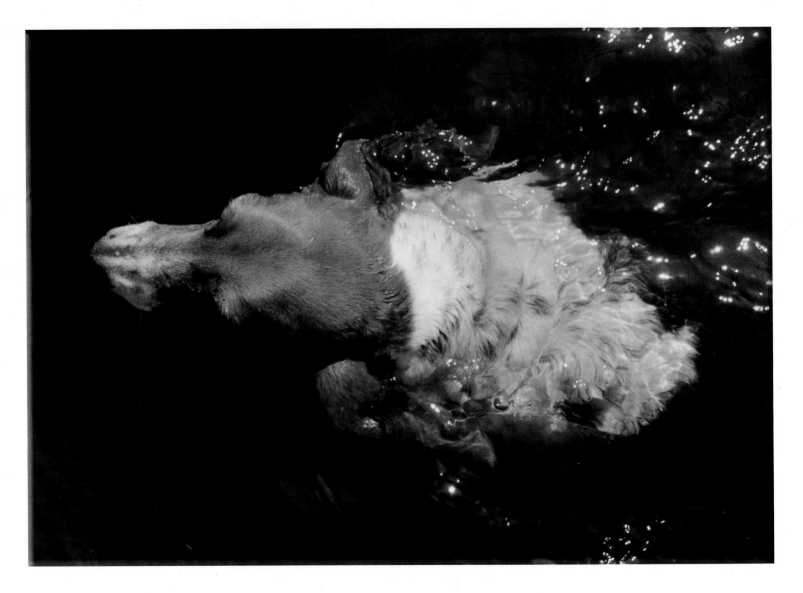

you sink to the muck.

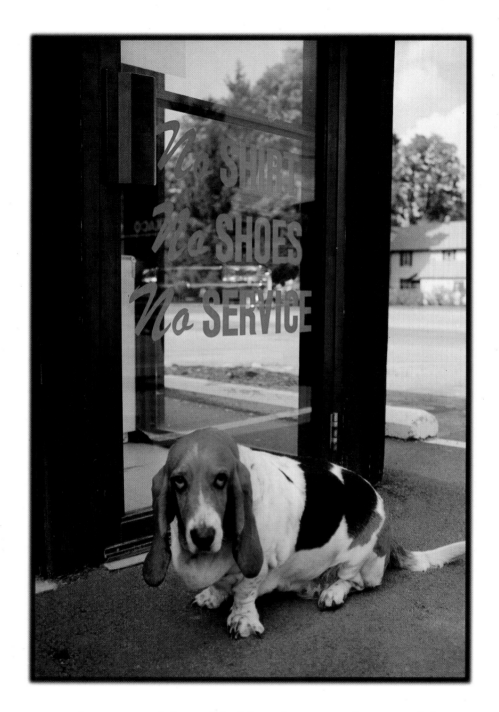

Sometimes positive thinking just crashes and burns.

The sun shines, the earth moves,

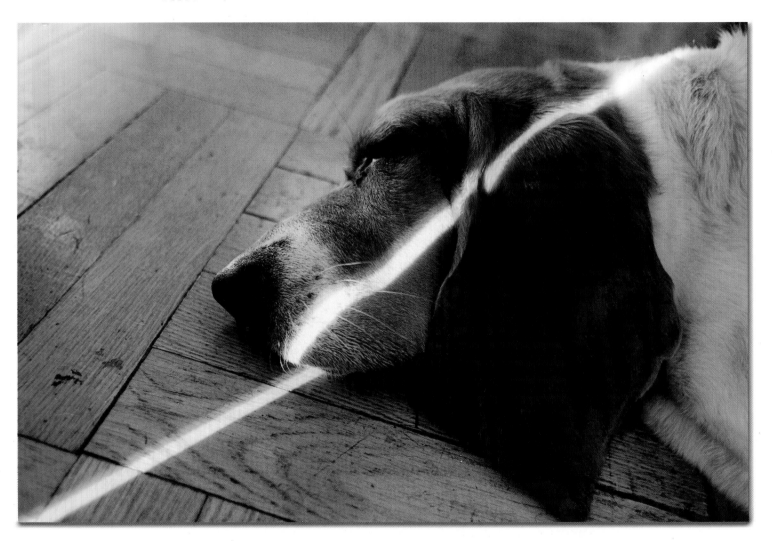

and for a moment we are illuminated.

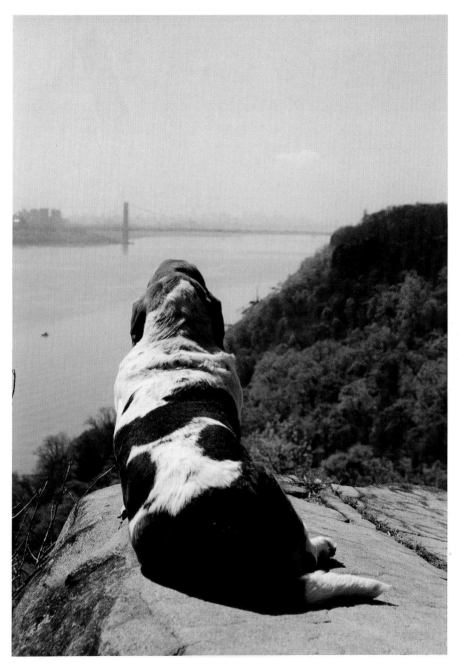

Contemplation is the highest form of action.

—*Socrates*

Party animal.

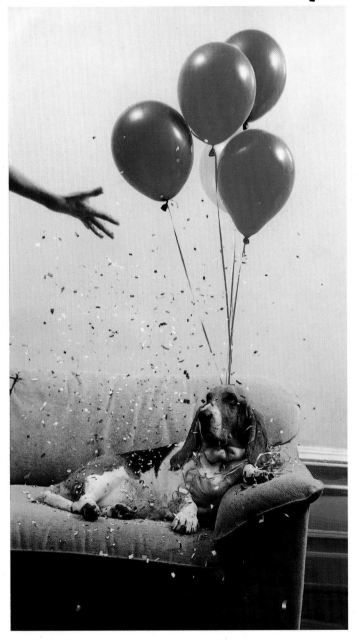 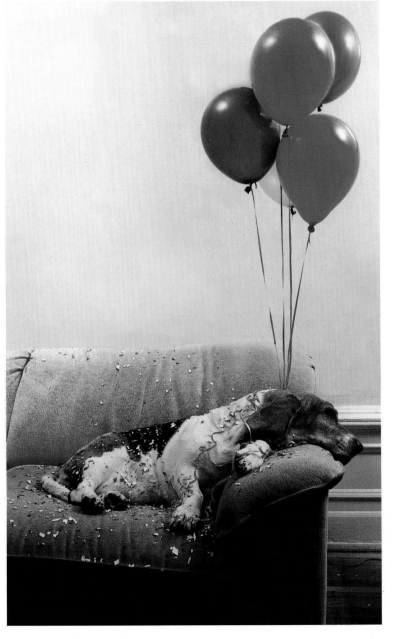

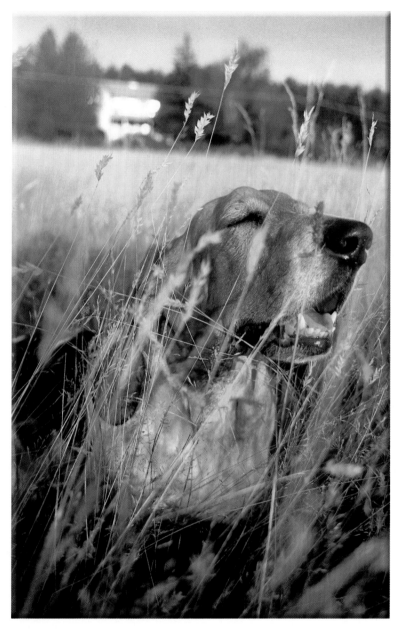

Summer afternoon—summer afternoon; to me those have always been the two most beautiful words in the English language.

—Henry James

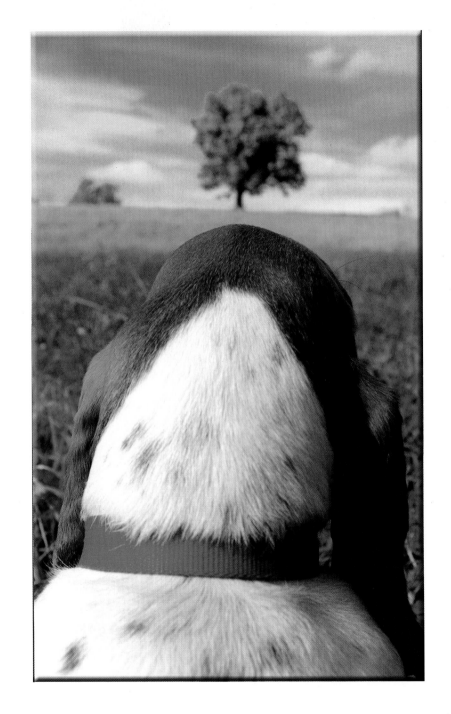

Adjust all accessories on a seasonal basis.

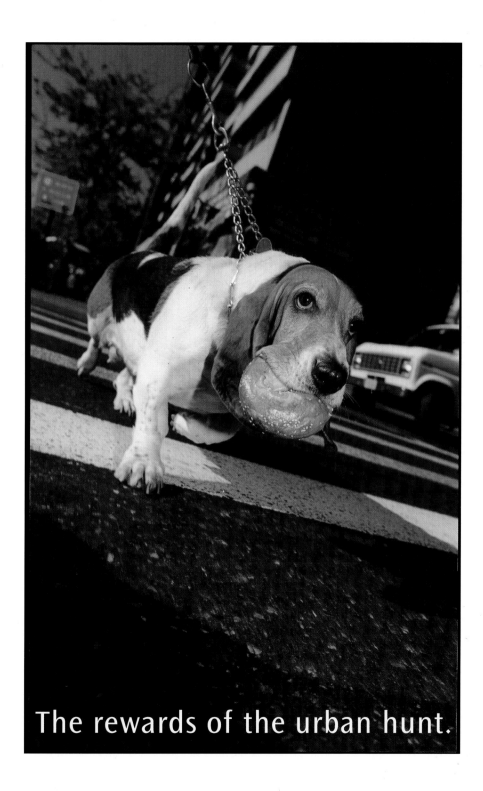

The rewards of the urban hunt.

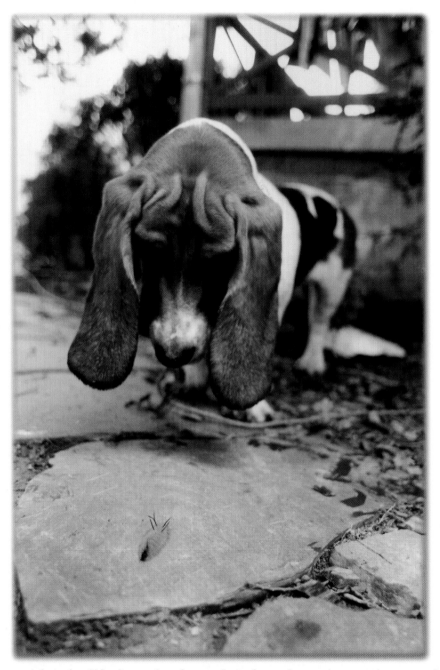

Nothing in life is to be feared. It is only to be understood.

—Marie Curie

Applied 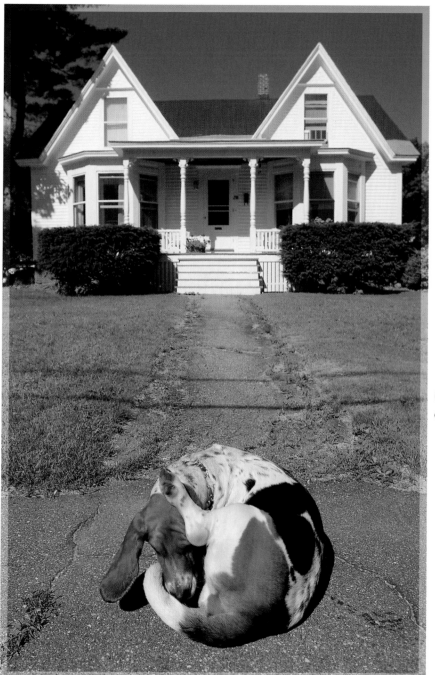 geometry.

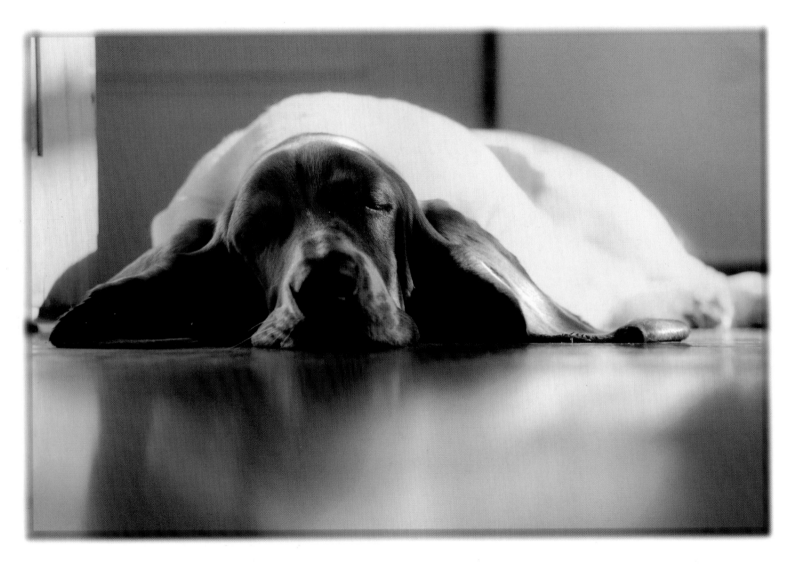

Dreaming permits us to be quietly and safely insane
every night of the week.

—William Dement

Did you ever have one of those days

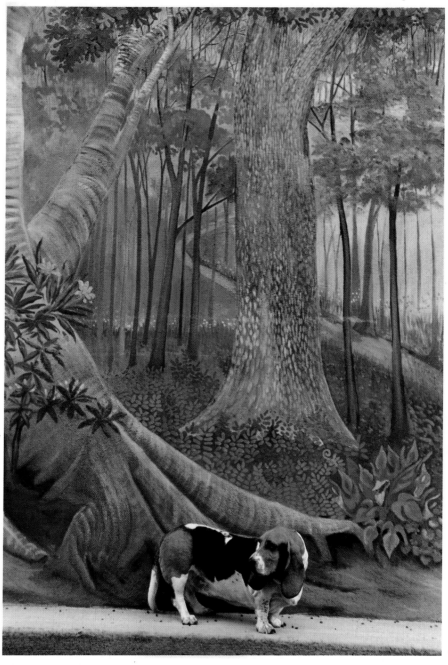

when everything looked right but smelled wrong?

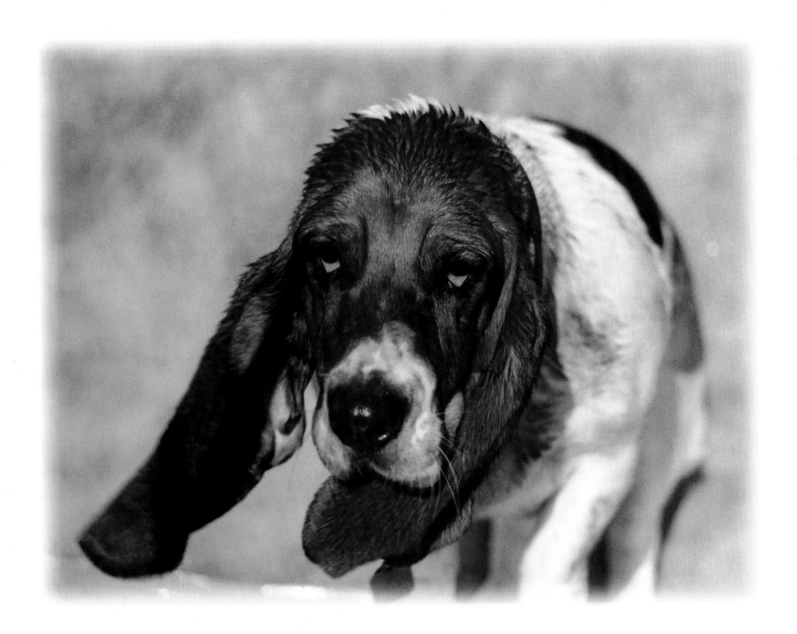

The pendulum effect.

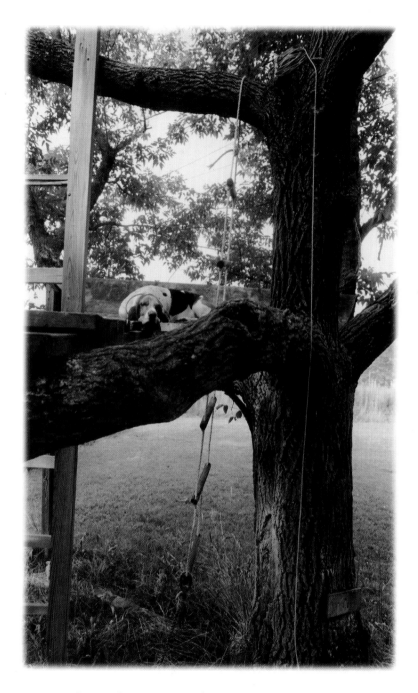

A bedroom is anywhere.

I'm an optimist. I see the glass as half full

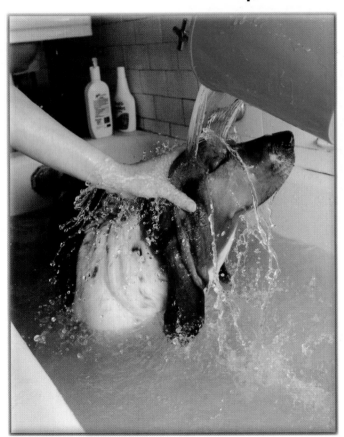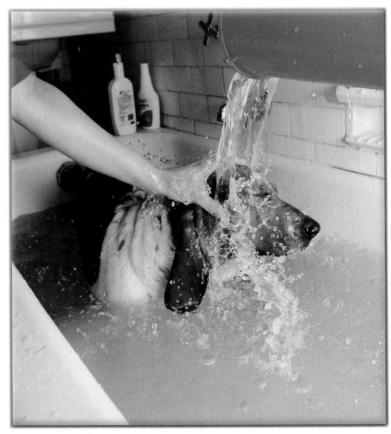

even when it's being poured on my head.

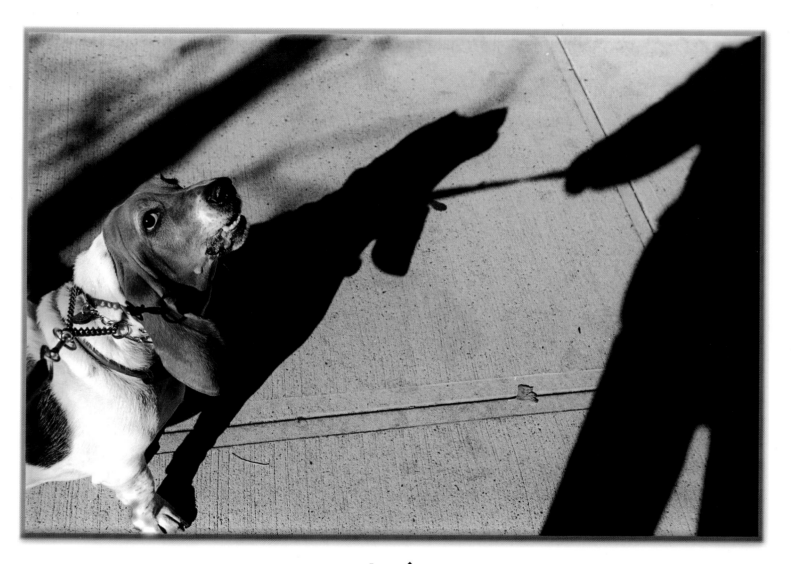

You may have a **chain** around my neck
but we both know who's in control here.

Sometimes it is necessary to draw a line in the sand

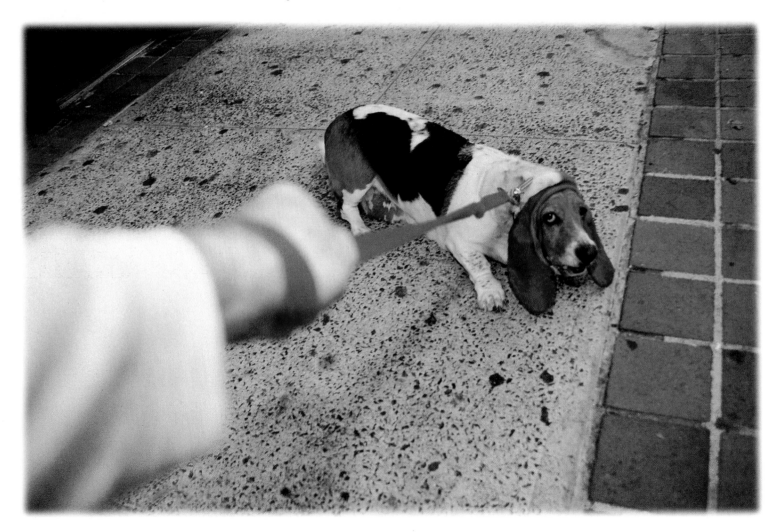

even when you are standing on a gum-encrusted sidewalk.

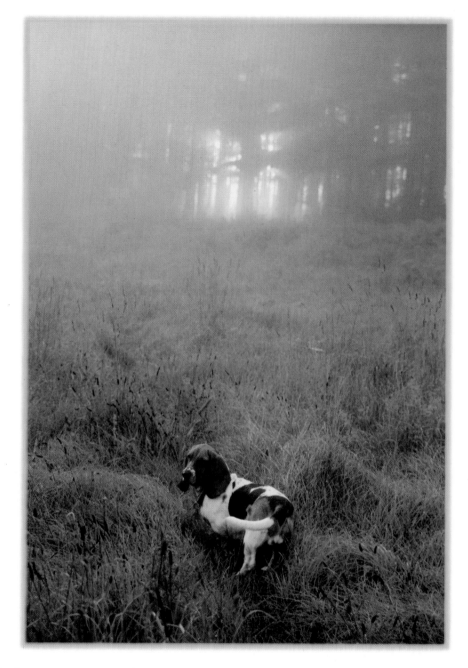

There is a shining moment in the morning when everything seems possible . . .
then the phone rings.

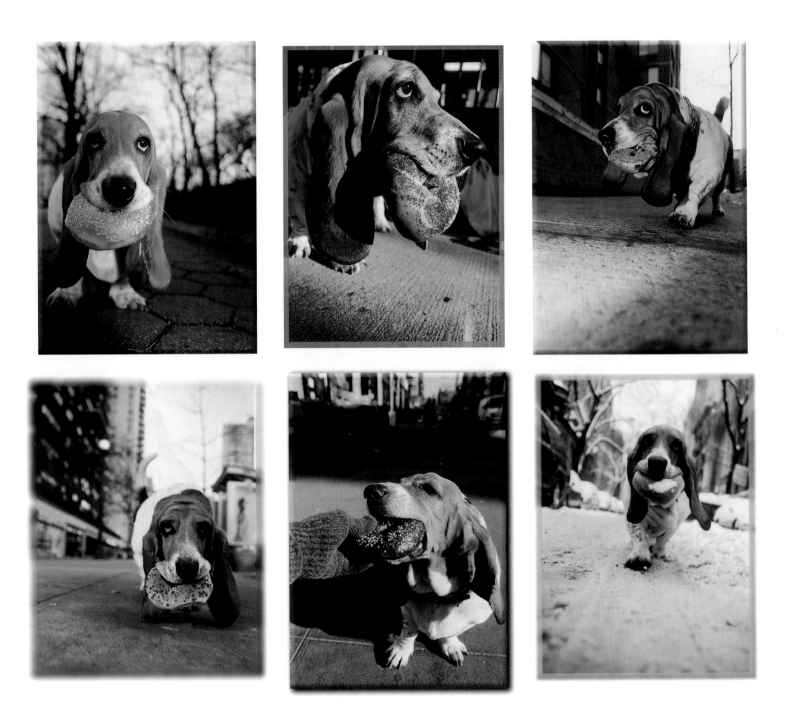

Assorted half dozen.

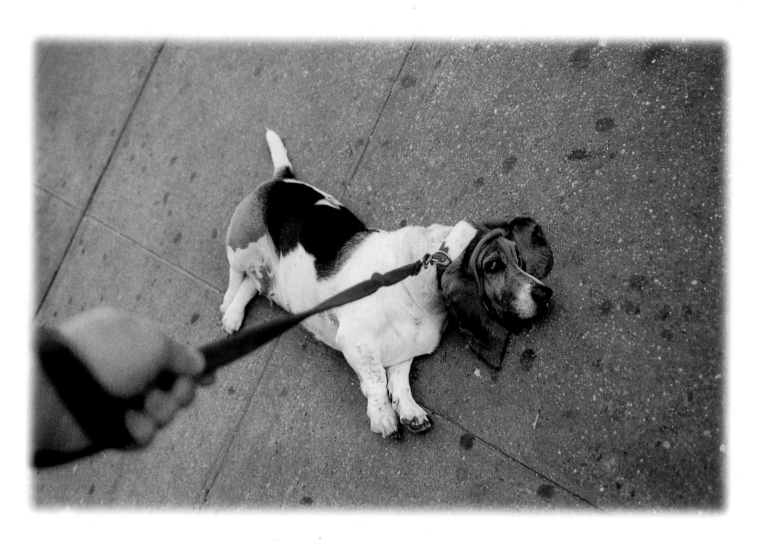

Body language.

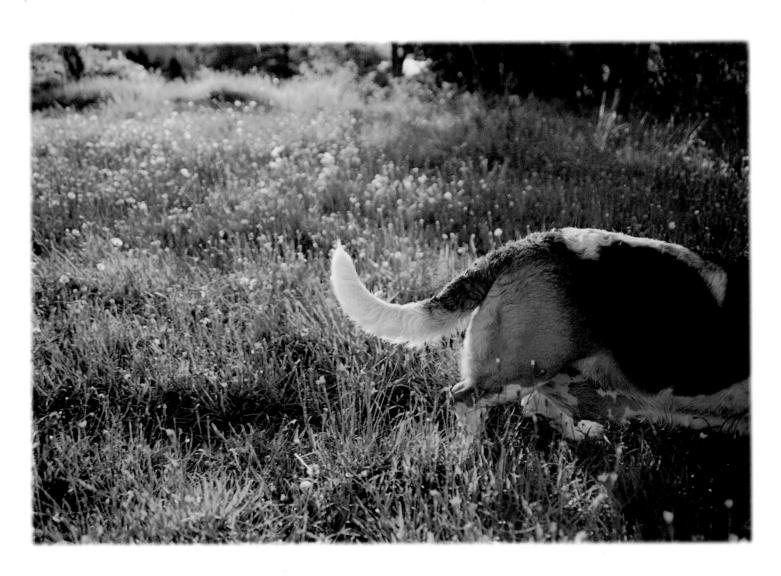

Field mice on high alert.

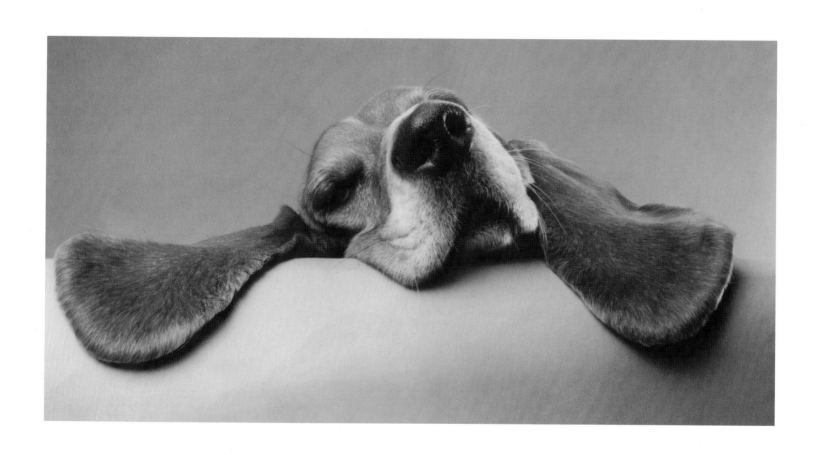

No day is so bad it can't be fixed with a nap.

—C. P. Snow.

It's not the destination. It's the journey.

—Henry David Thoreau

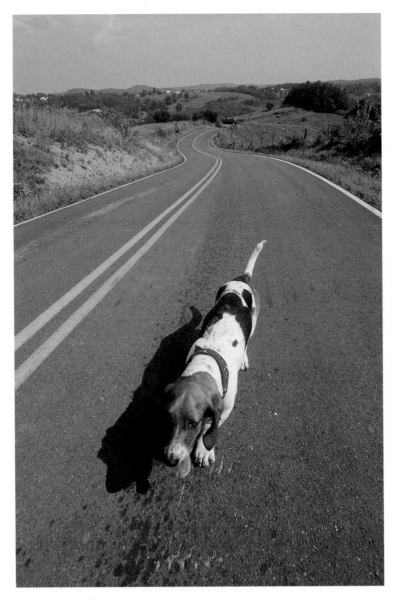

Yeah, well, I bet this Thoreau guy never walked barefoot on sunbaked asphalt.

—Maggie

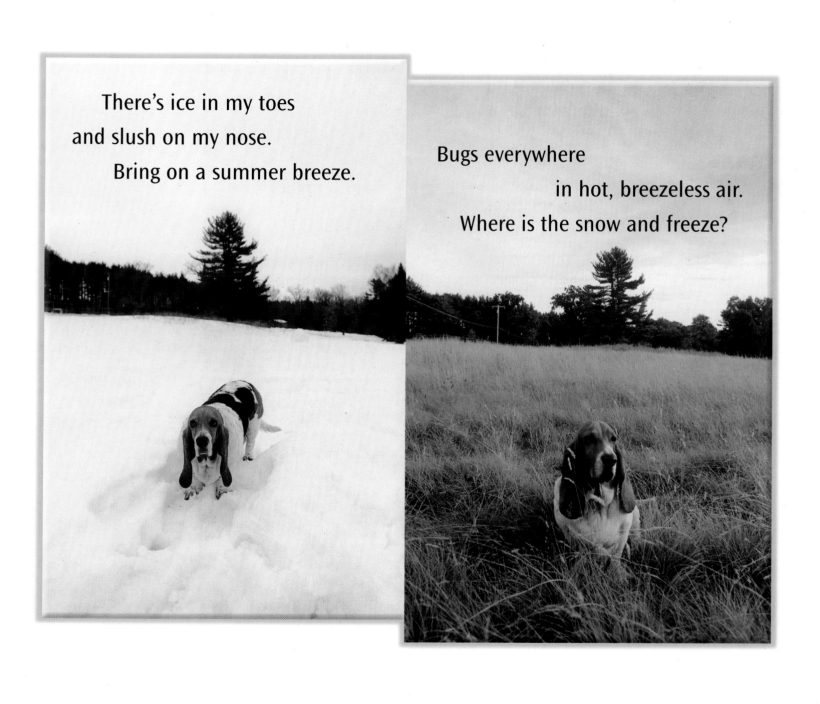

There's ice in my toes
and slush on my nose.
Bring on a summer breeze.

Bugs everywhere
in hot, breezeless air.
Where is the snow and freeze?

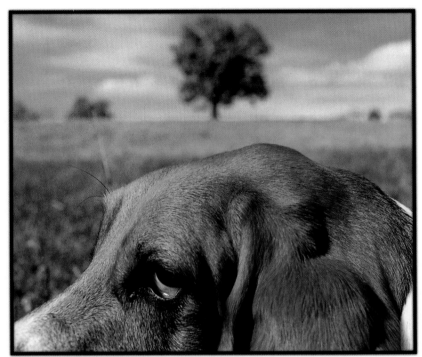

Form and function.

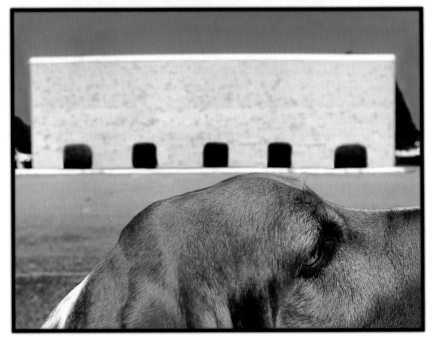

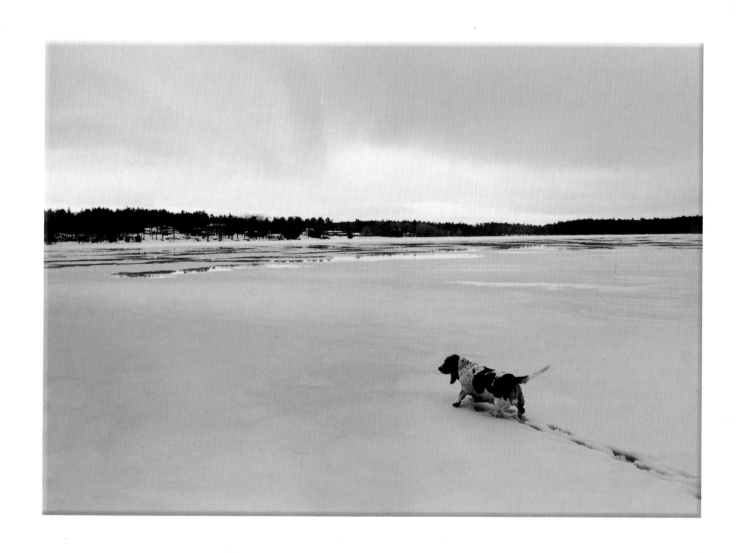

Not all who wander are lost.

—J. R. R. Tolkien

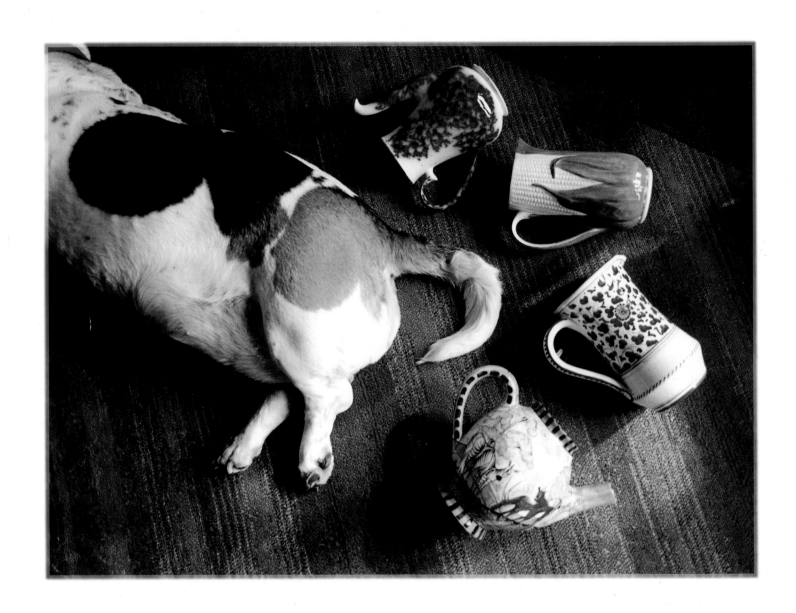

The pitcher collection.

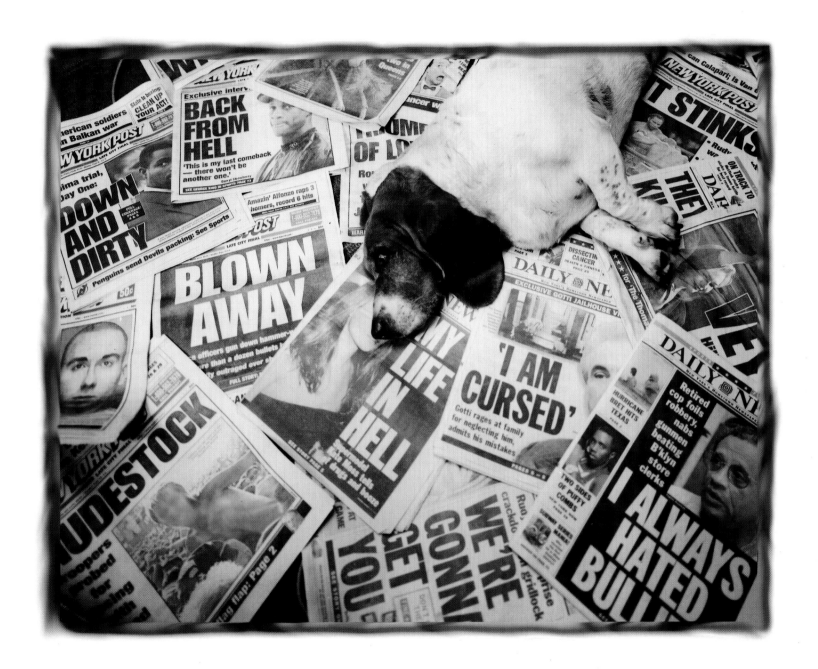

Staying current.

Winter is on my head but eternal spring is in my heart.

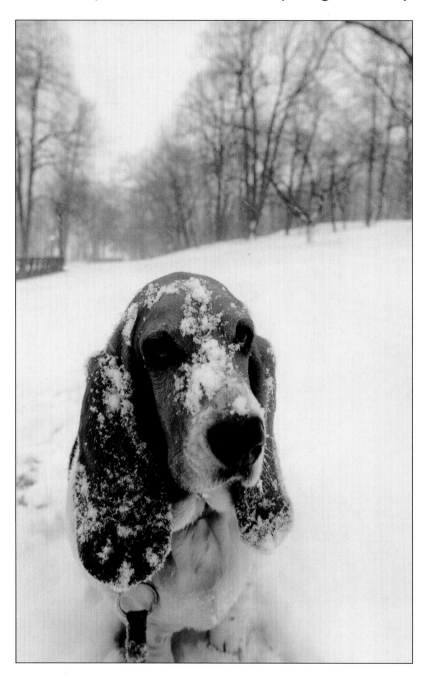

—Victor Hugo

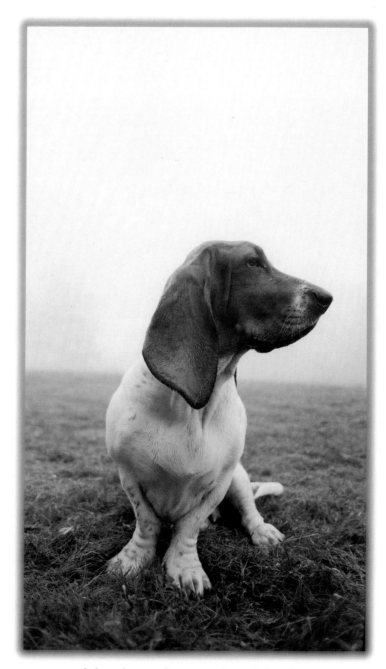

Noble thoughts and noble deeds
do not necessarily emanate from a noble profile.

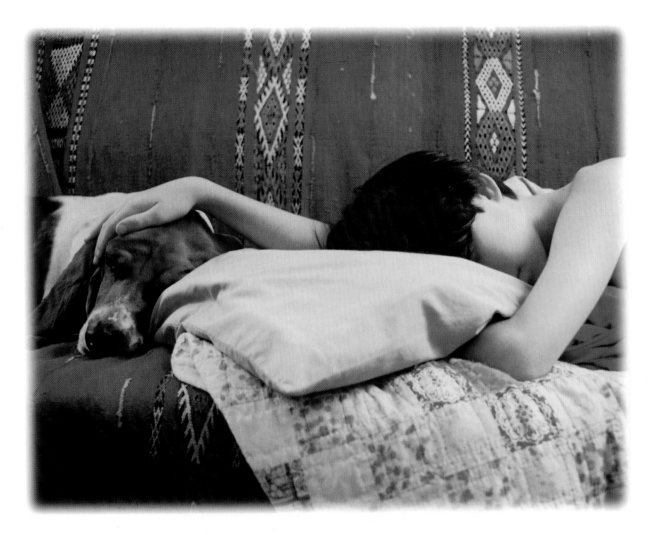

One need not be conscious to savor the touch of a friend.

Do it big

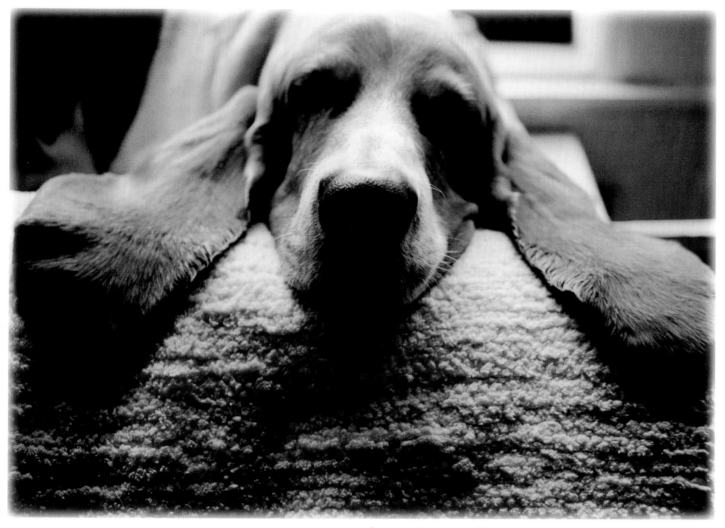

or stay in bed.

—Larry Kelly

Sometimes I sits and thinks

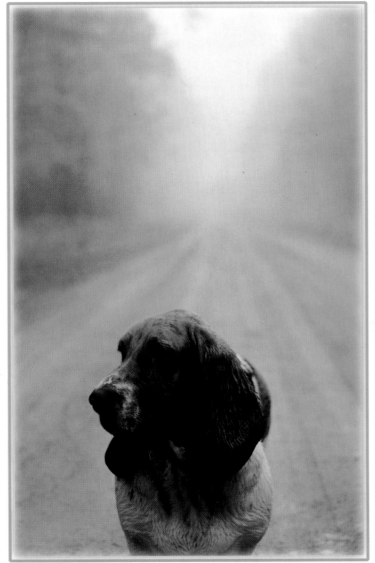

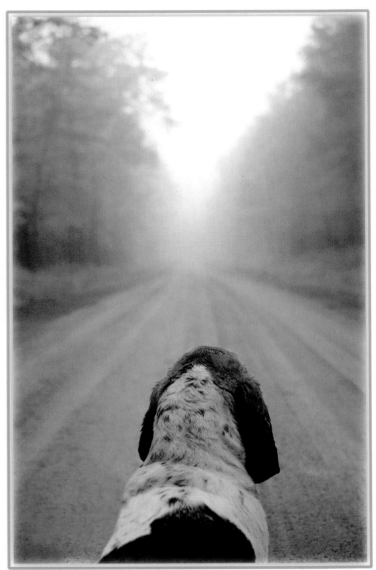

and sometimes I just sits.

—Satchel Paige

My life

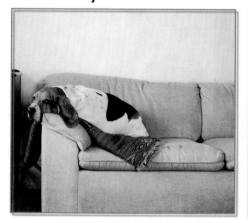 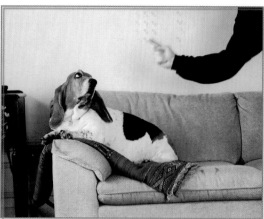 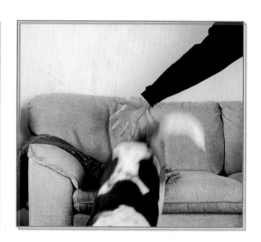

is a series

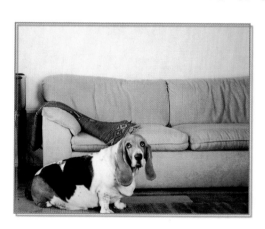 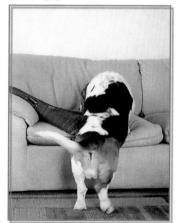 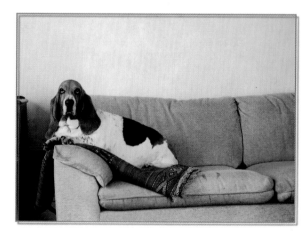

of interruptions.

The journey

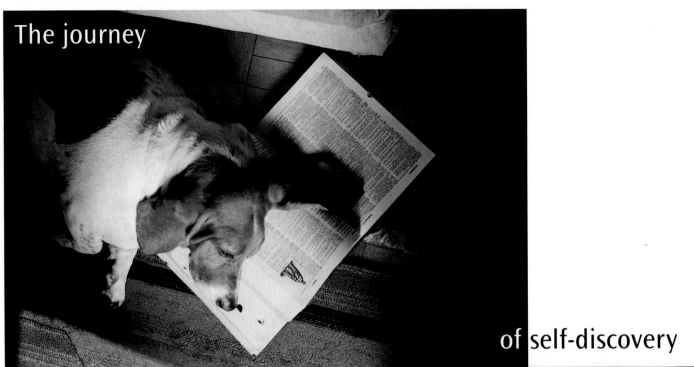

of self-discovery

is an arduous one

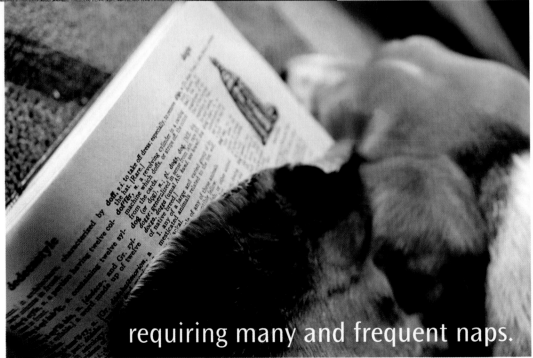

requiring many and frequent naps.

The five stages of change:

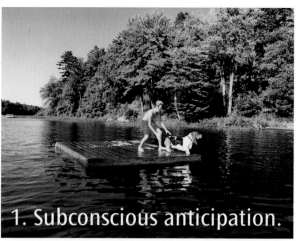

1. Subconscious anticipation.

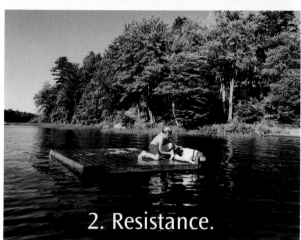

2. Resistance.

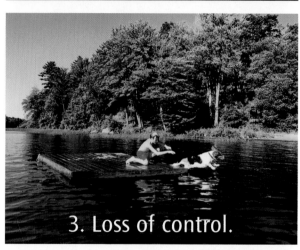

3. Loss of control.

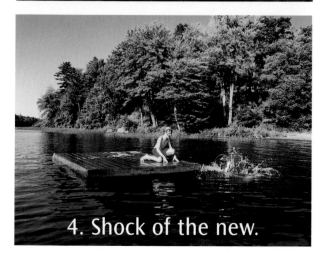

4. Shock of the new.

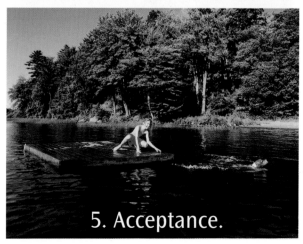

5. Acceptance.

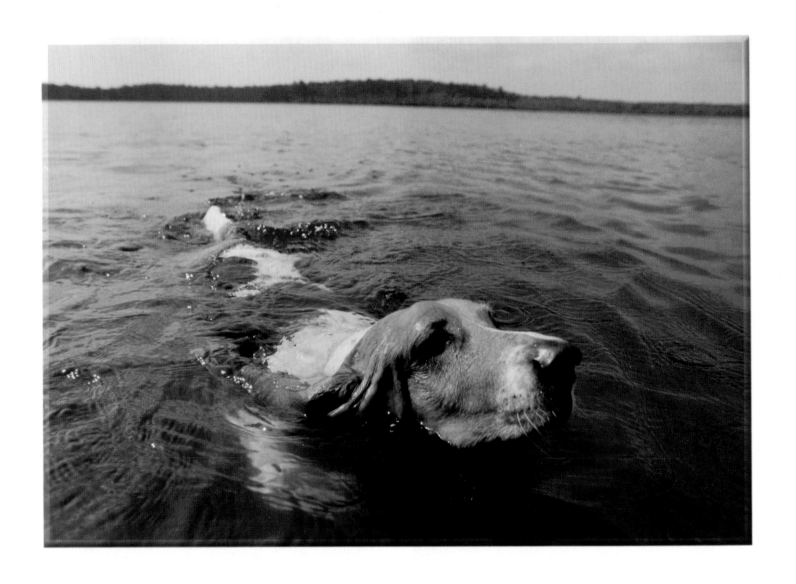

Go as the way provides.

—Quaker proverb

It came from the sea.

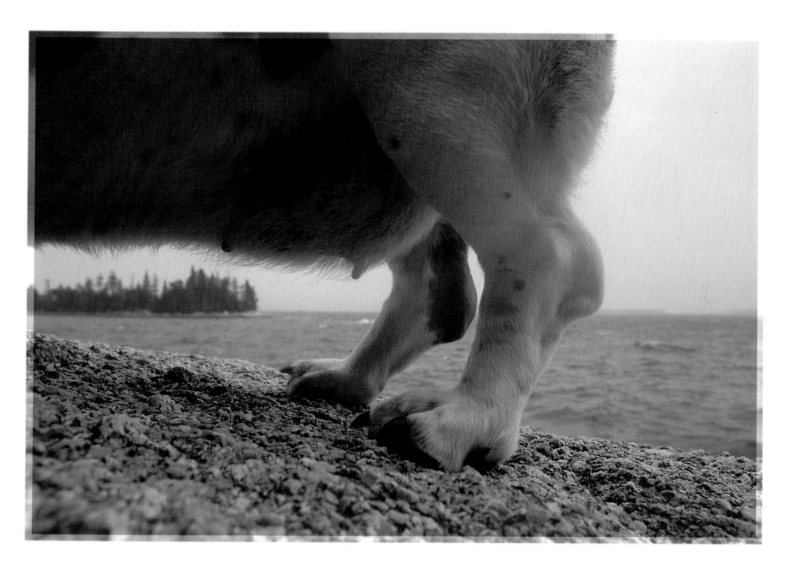

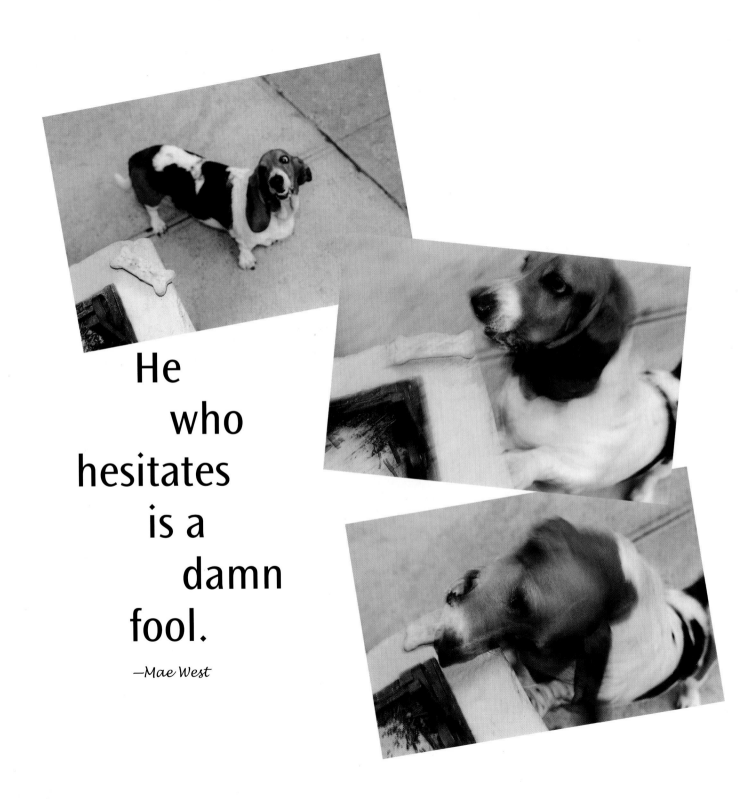

He
who
hesitates
is a
damn
fool.

—Mae West

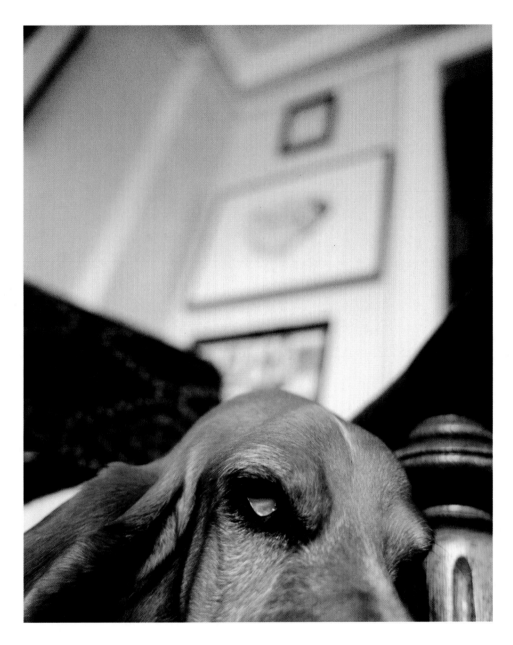

Life is something to do when you can't get to sleep.

—Fran Lebowitz

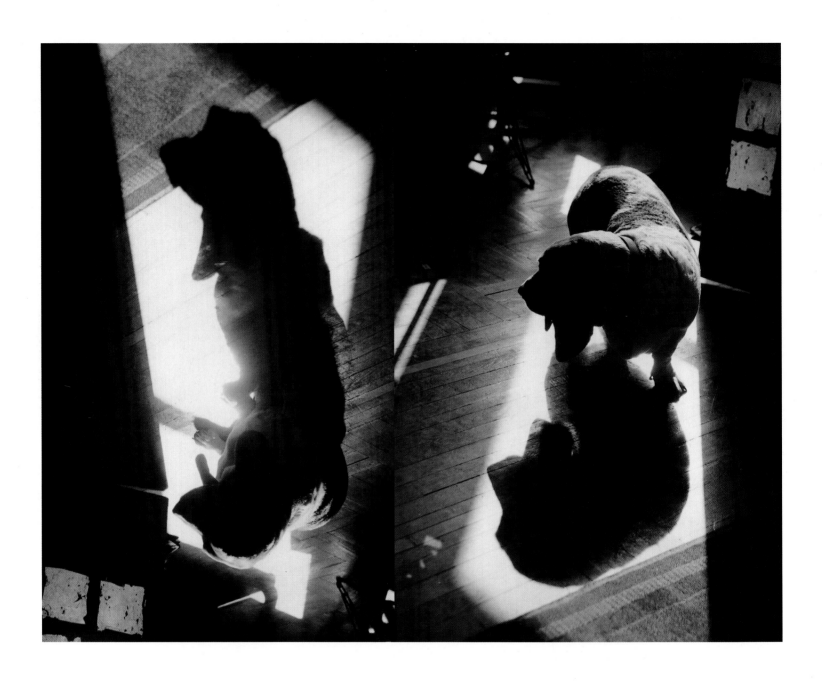

Reality is an illusion, albeit a persistent one.

—*Albert Einstein*

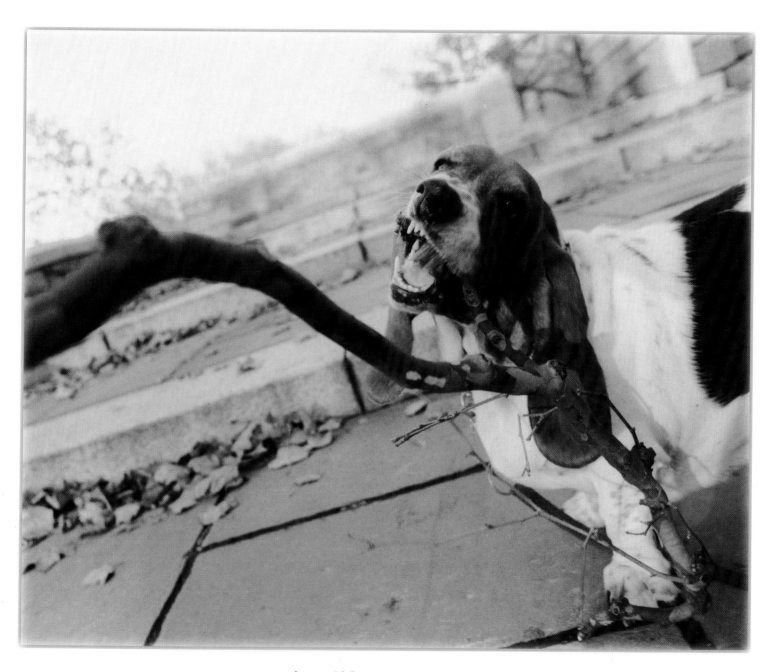

To enjoy life, take big bites.

—Robert Heinlein

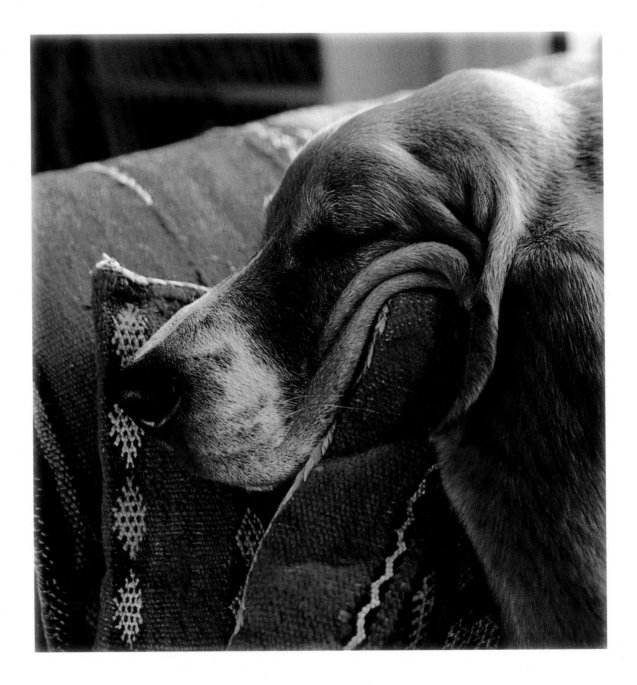

Make the adjustments necessary to obtain short-term goals.

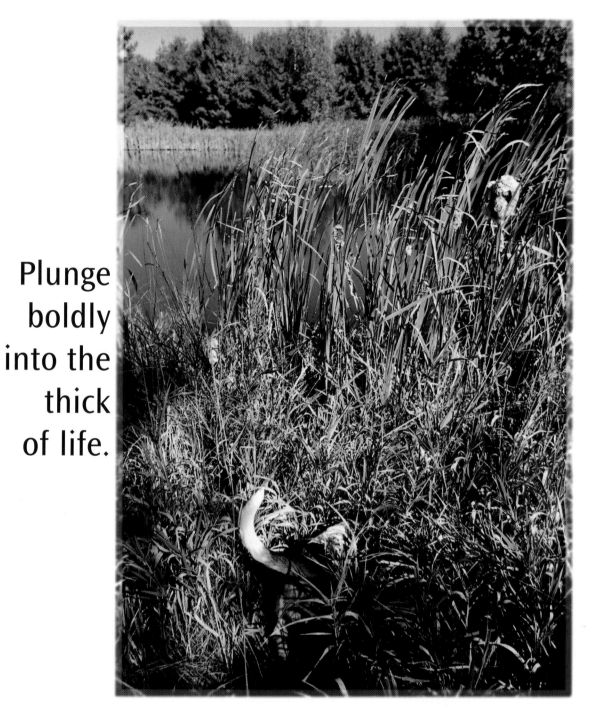

Plunge
boldly
into the
thick
of life.

—*Johann Wolfgang von Goethe*

There is a

cosmic rhythm

in a good walk.

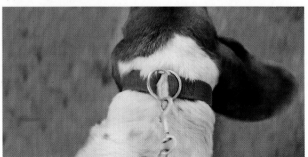

The greatest revelation is stillness.

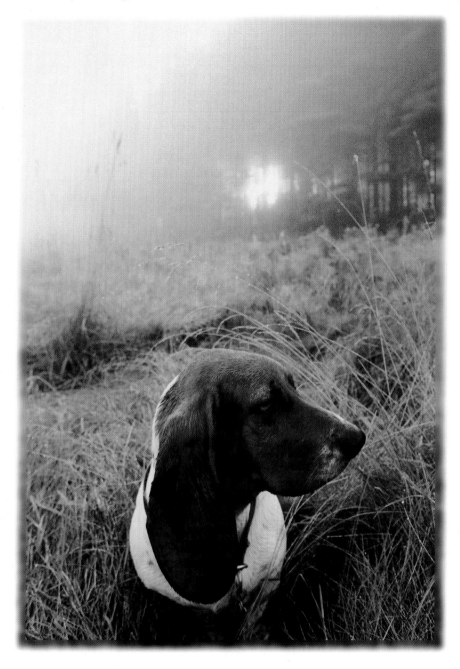

—Lao-tzu

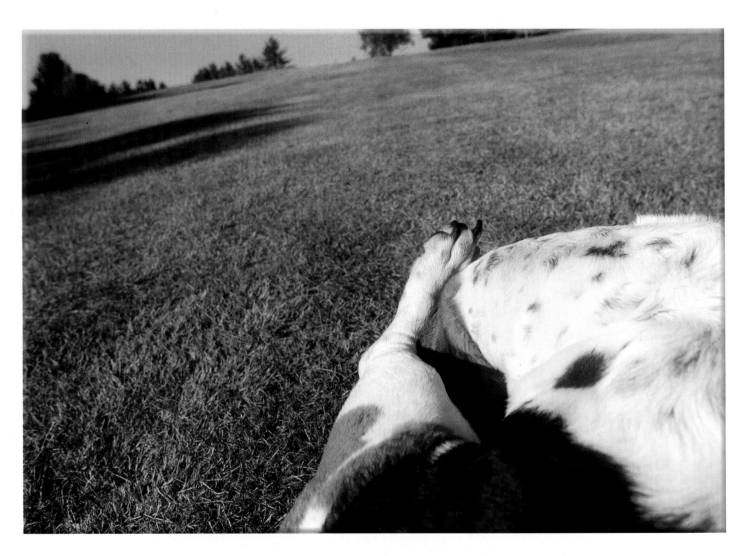

One can never be too clean.

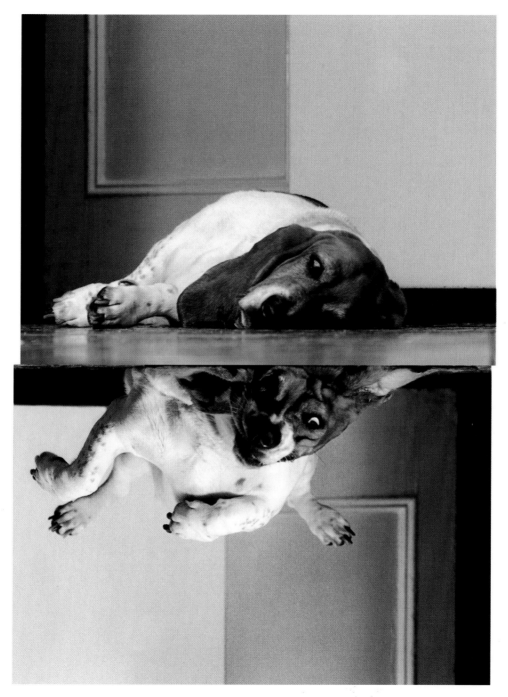

There's a flip side to everything.

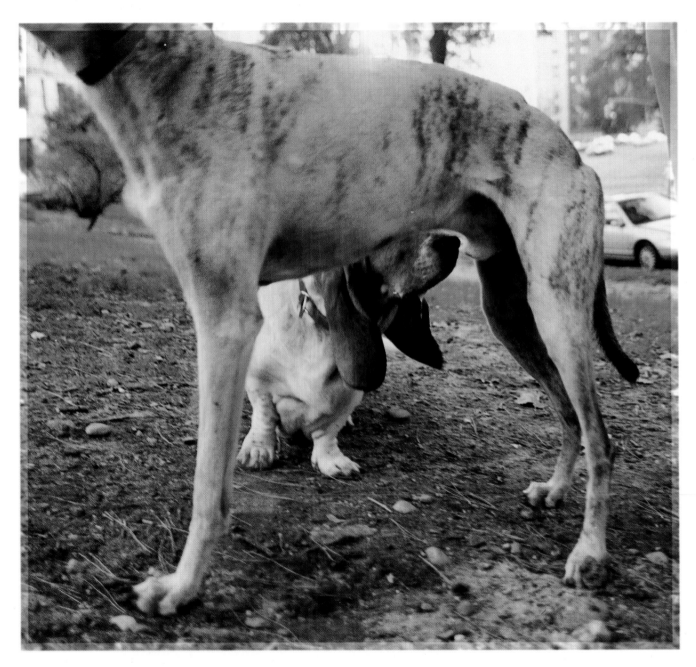

There are certain advantages to being an underdog.

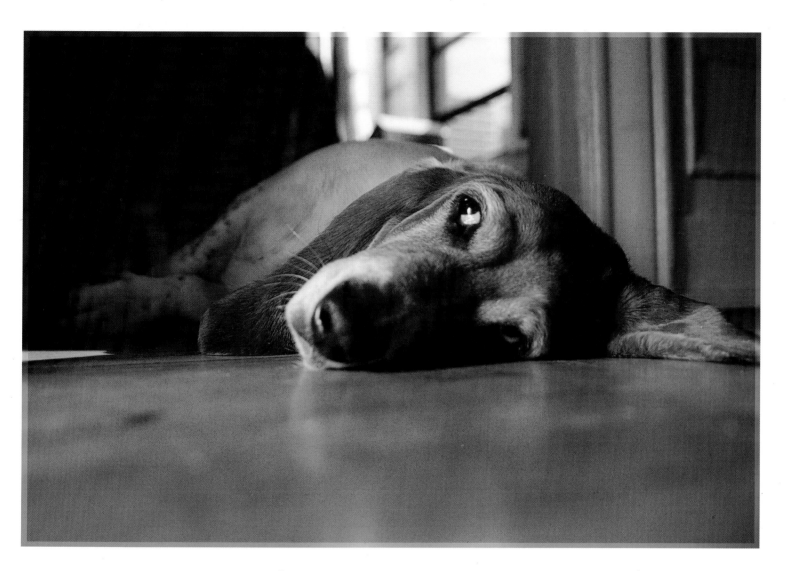

As feet approach.

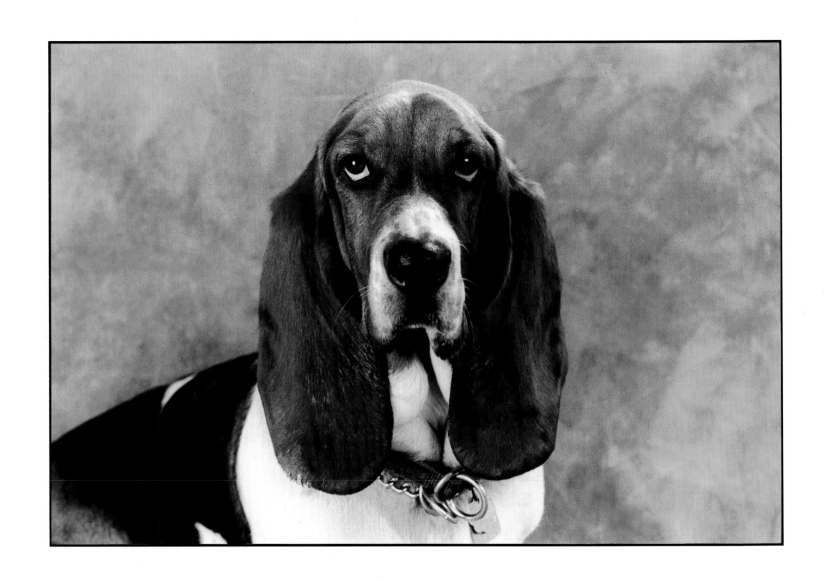

When angry, count to four.
When very angry, swear.

—*Mark Twain*

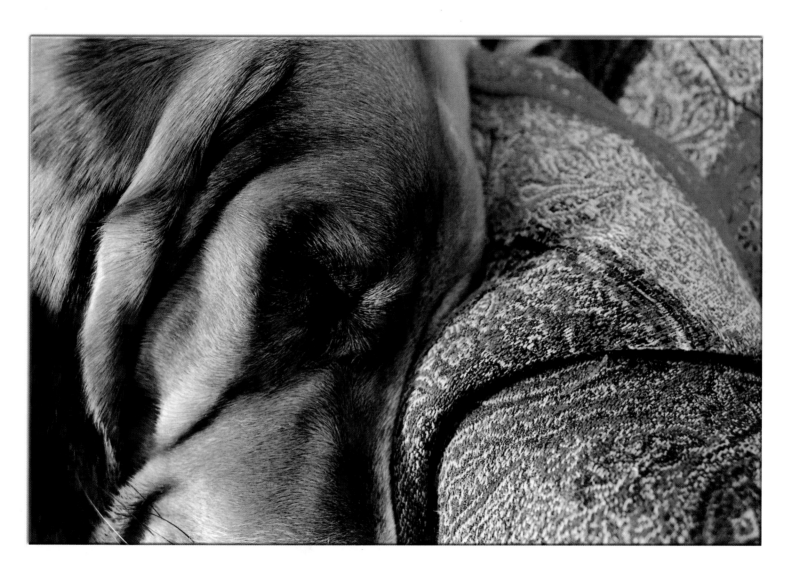

Dreamscape.

All things come to those who wait,

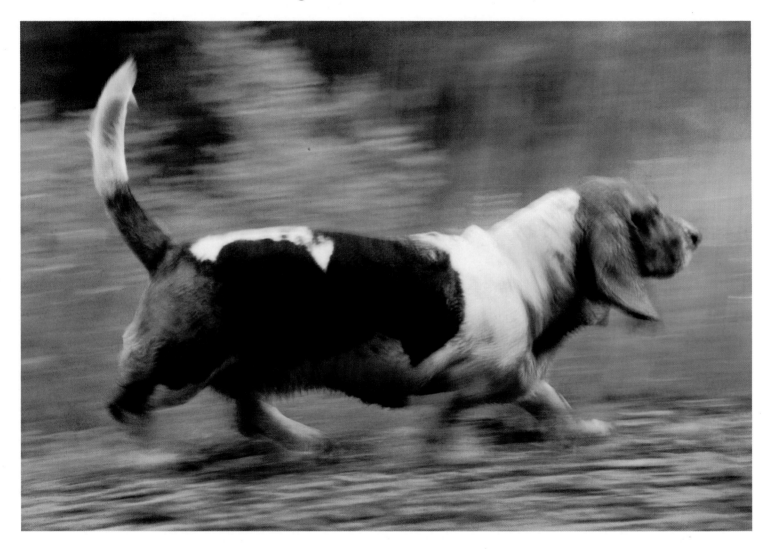

but usually what's left over from those who hustle.

—Abraham Lincoln

The

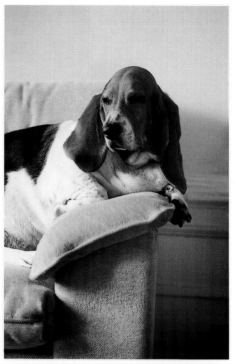

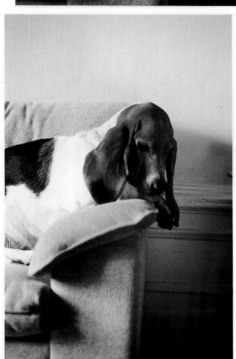

irresistible

force.

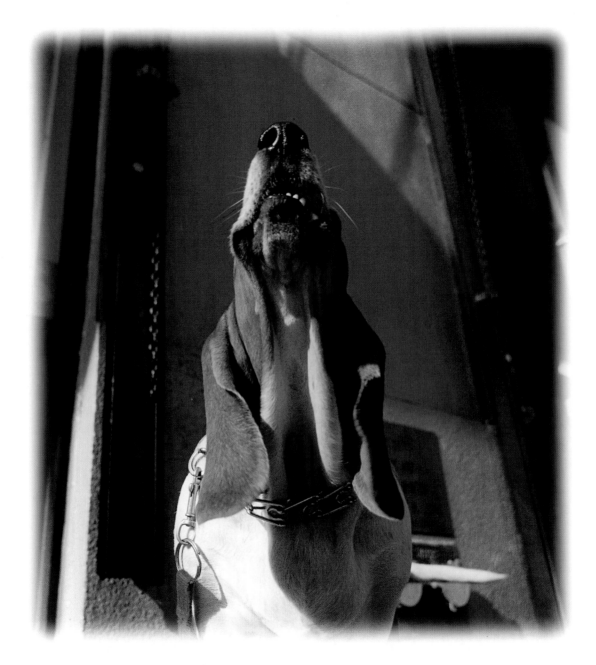

Better to remain silent and thought a fool
than to speak out and remove all doubt.

—Abraham Lincoln

If you can't fight and you can't flee,

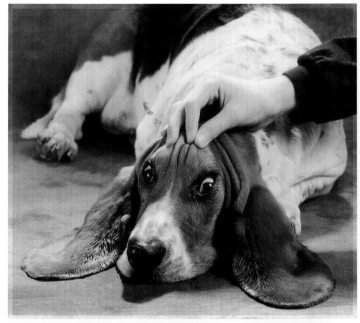 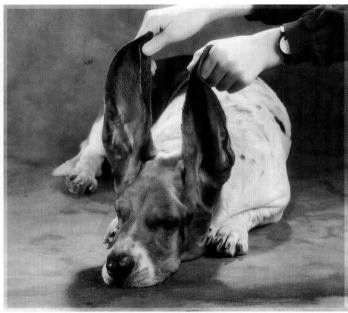

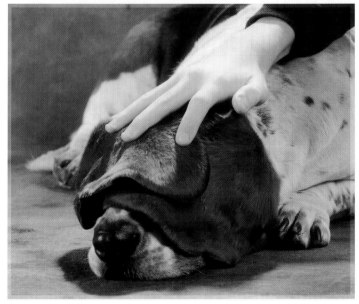 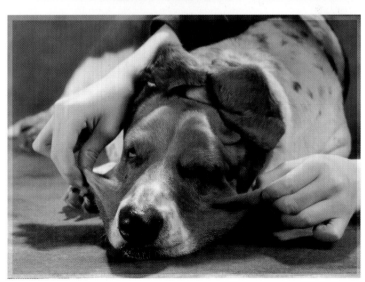

f l o w .

One experiences everything quite differently when one is warm

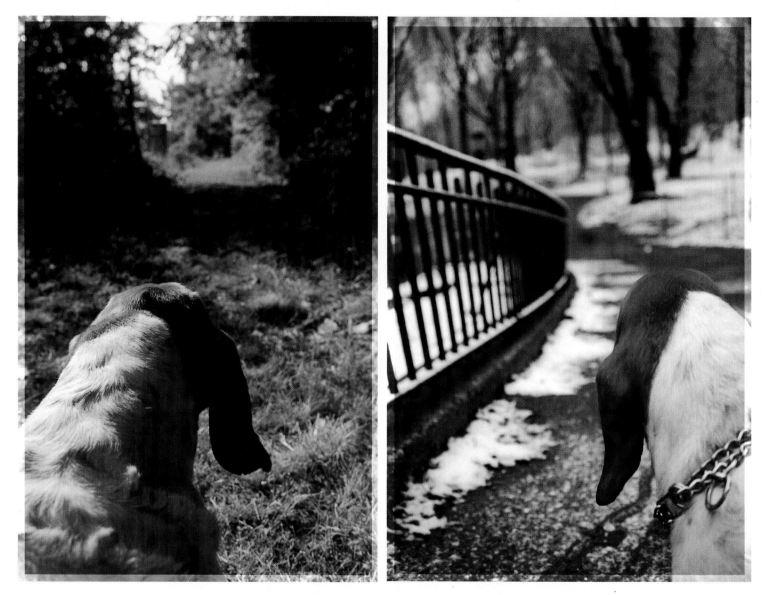

than when one is cold.

—Edvard Munch

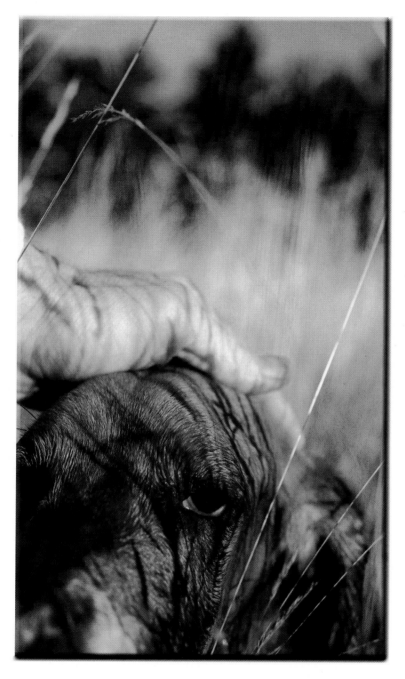

Affection is never wasted.

—Lord Byron

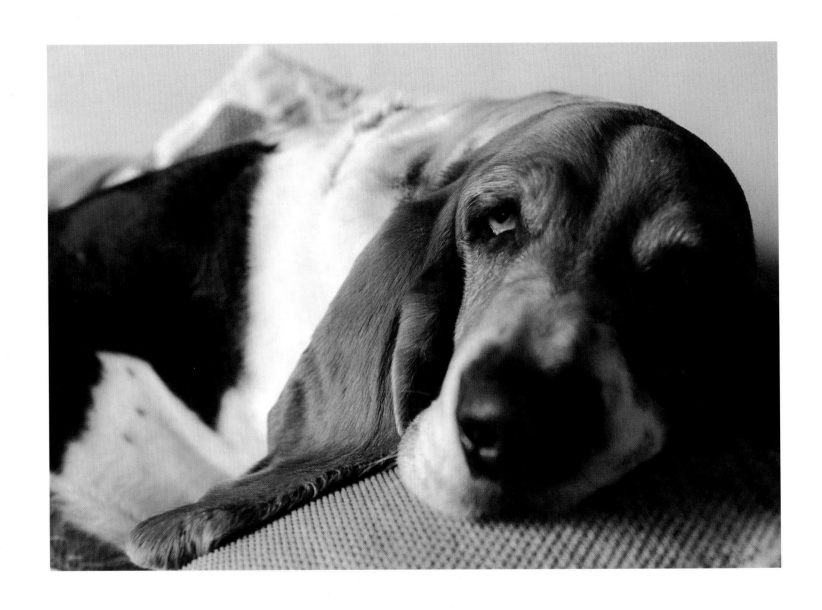

It's better to have loafed and lost than never to have loafed at all.

—*James Thurber*

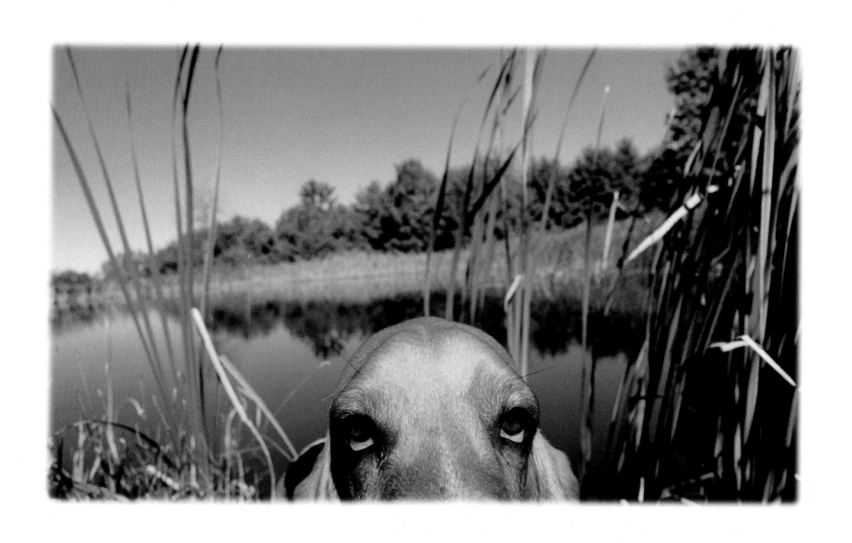

swamp thing.

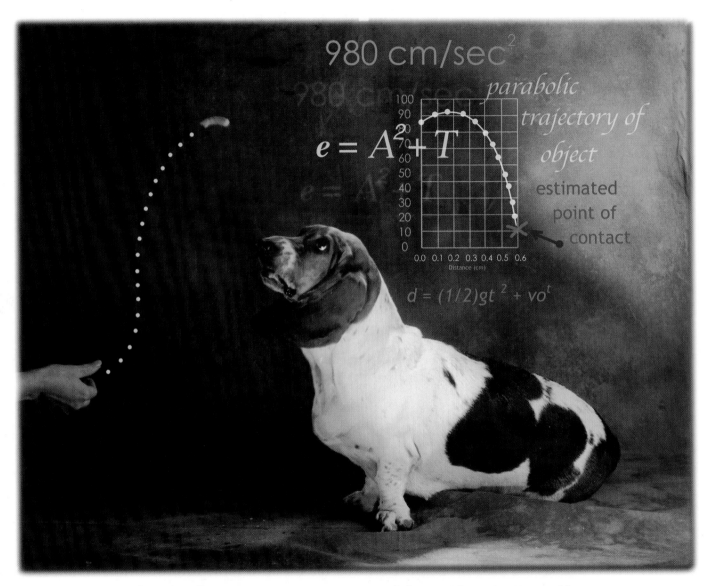

Calculations on an approaching Cheez Doodle.

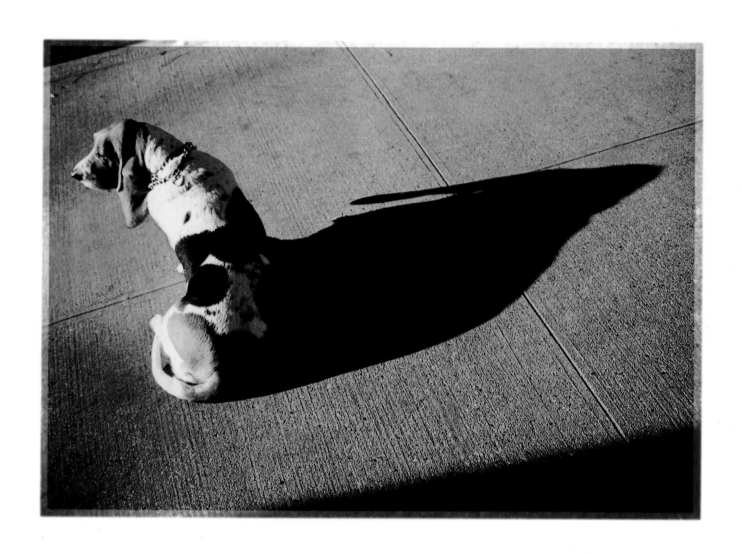

Let your quiet mind listen and absorb.

—Pythagoras

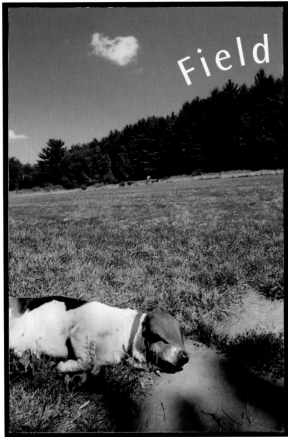

Field of dreams.

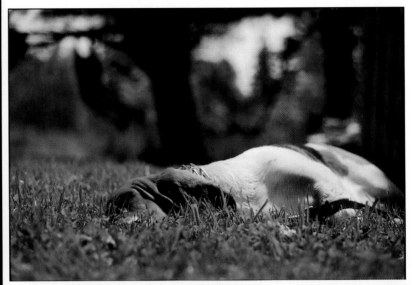

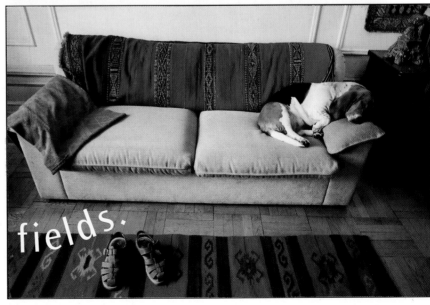

Dreams of fields.

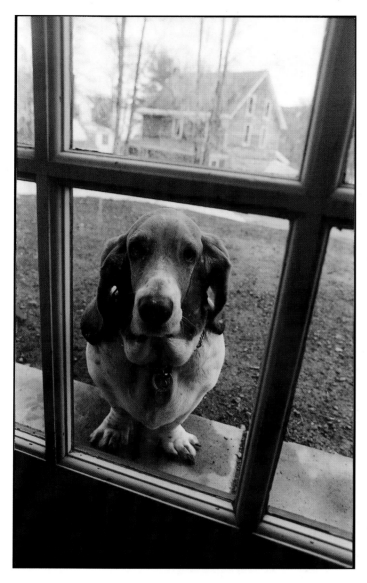

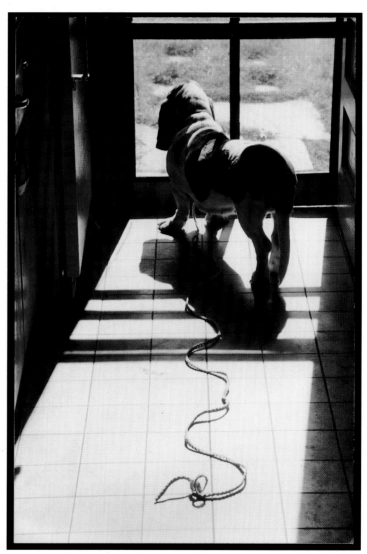

Happiness for a dog is what lies

on the other side of the door.

—Charlton Ogburn Jr.

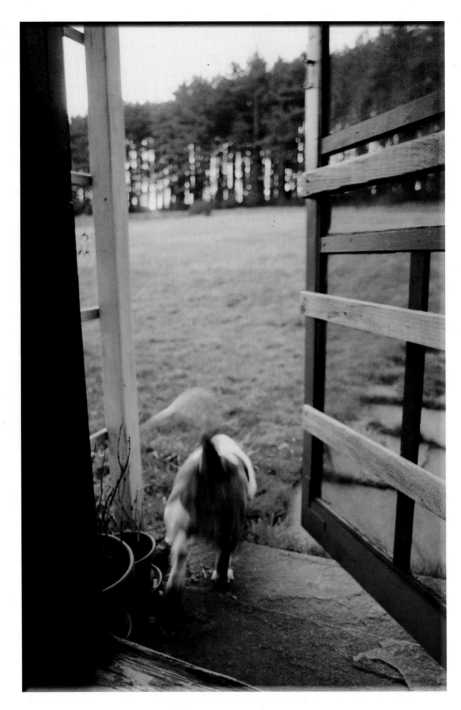

The day will begin whether or not you get up.

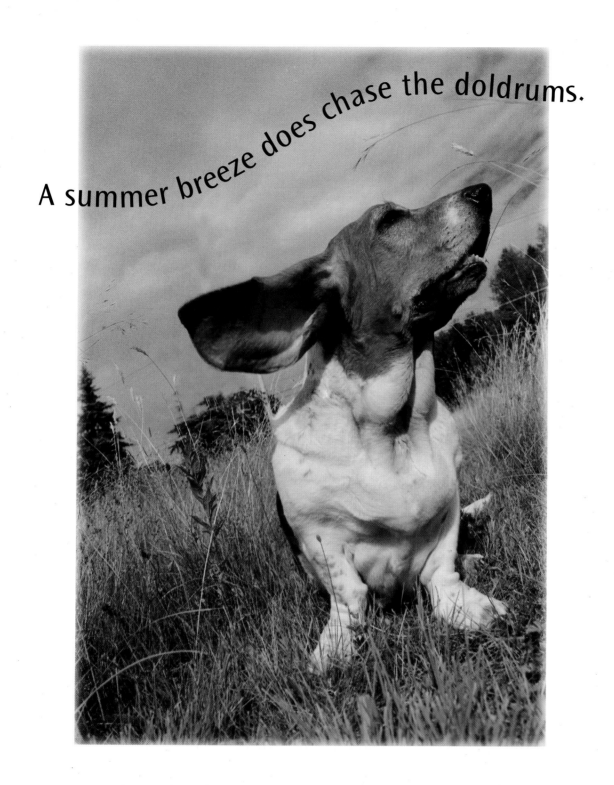

A summer breeze does chase the doldrums.

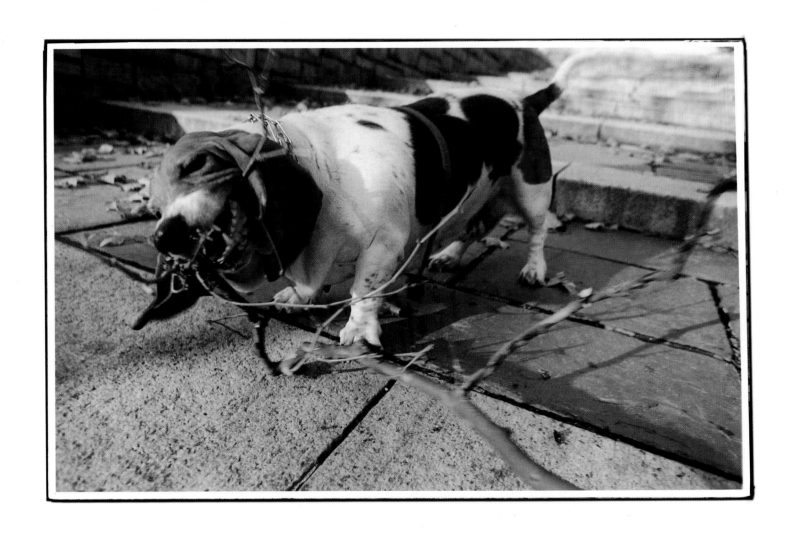

Life is short. Live it up.

—Nikita Khrushchev

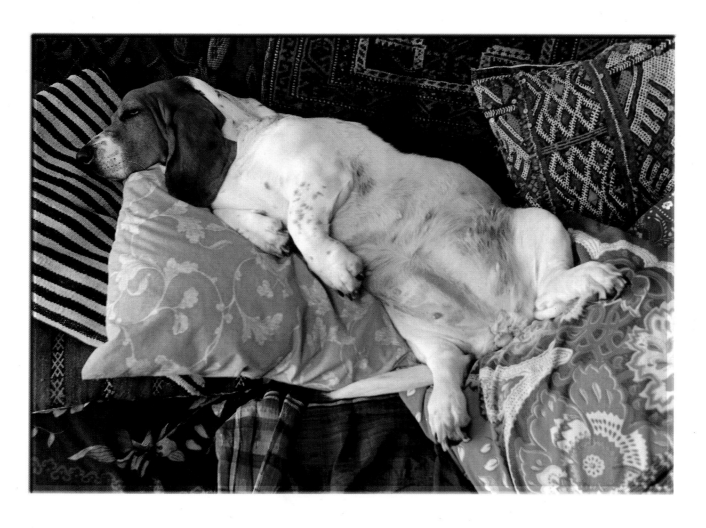

Laziness is just the habit of resting before fatigue sets in.

—Jules Renard

The scent of a dream.

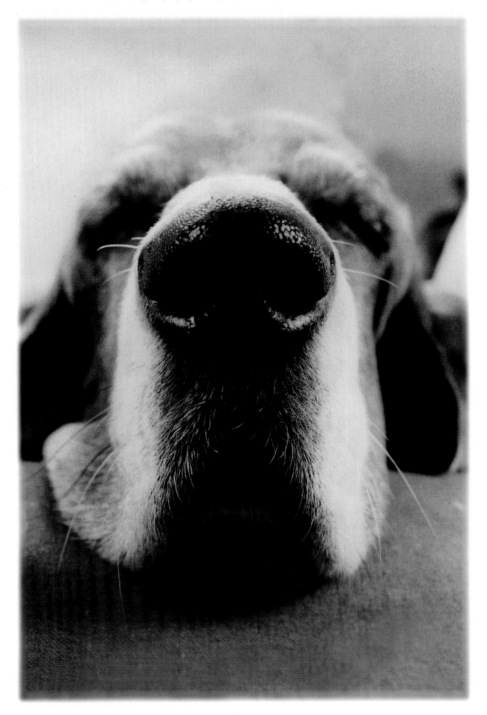

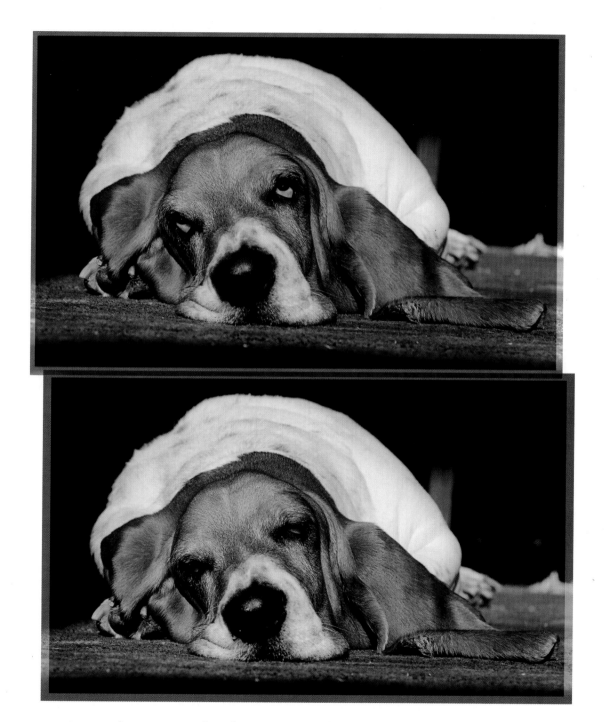

Consciousness is that annoying time between naps.

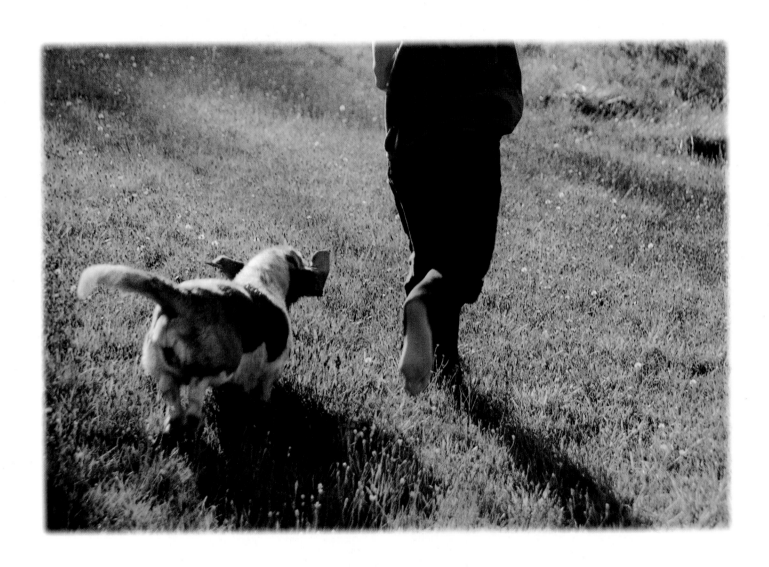

When dogs run free.

Every exit is an entrance somewhere else.

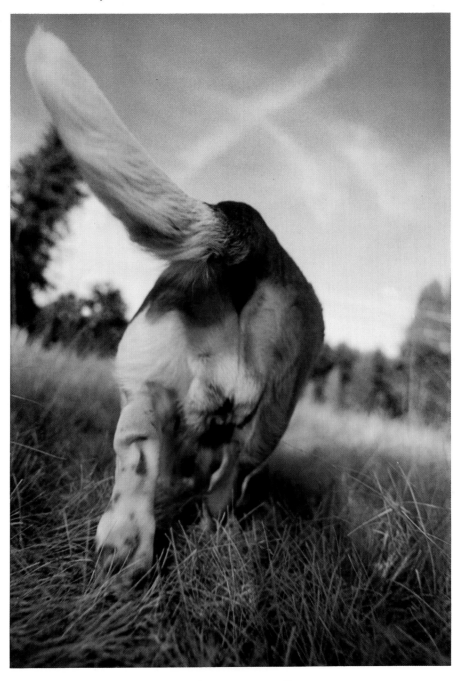

—Tom Stoppard